Handcoloring Photographs

Step by Step

Sandra Laird & Carey Chambers

AMHERST MEDIA, INC. ■ BUFFALO, NEW YORK

Published by:
Amherst Media, Inc.
P.O. Box 586
Buffalo, NY 14226
Fax: 716-874-4508

Publisher: Craig Alesse
Editor/Designer: Richard Lynch
Associate Editor: Frances J. Hagen
Editorial Assistant: Amanda Egner
All photographs by Sandra Laird, unless otherwise noted.

ISBN: 0 936262-54-0
Library of Congress Catalog Card Number: 96-079314

Printed in the United States of America
10 9 8 7 6 5 4 3 2 1

Table of Contents

Introduction

"...handcoloring is easy to learn, creatively satisfying and an immensely enjoyable artistic experience."

Why Handcolor?

Thanks to the wonder of modern technology, today's photographer heads into the twenty-first century with a full bag of tricks for manipulating the final look of a photograph. This includes a staggering selection of film and equipment, new and inventive darkroom techniques — even computer scanning and imaging. So why in this day and age would anyone want to color a black & white photograph by hand?

Unlike the technical methods and digital manipulations technology has made possible, handcoloring is a pure and simple artistic process. With brush and color you take complete hands-on creative control over your photographic image. You decide whether apples are red, yellow or pink with purple spots. In your photographic world, skies can be blue, gray, orange or neon green. When handcoloring, you're free to interpret black & white images any way your heart desires. All you need is a few inexpensive art supplies. Best of all, handcoloring is easy to learn, creatively satisfying and an immensely enjoyable artistic experience.

The Black & White Photograph's Colorful Past

In 1826, Nicephone Niepce of France produced the world's first photograph. As impressive as this was at the time, the photograph did not register color, just black and white. To the frustration of thousands of photographers, inventors and photo collectors more than a hundred years would pass before color photography became commonplace.

Refinements on Niepce's work led to the development of the daguerreotype in 1839, the first common black & white photographic type. In the decades that followed, photographers shot daguerreotype portraits by the thousands and turned to handcoloring as a way to add life and realism to their work. Using camel hair brushes, handcolorists (often painters by trade) carefully applied dry powders to the images adding hints of color to clothing, face and hair. Handcoloring daguerreotype plates was tricky business: the plates were extremely delicate and easily damaged. Handcoloring became easier some years later with the development of the first paper photographic process: the calotype. Now handcolorists could use readily available artist media — primarily oil and watercolor paints — to color images with gusto!

The search for the elusive true-color photograph pressed on through the remainder of the nineteenth century. Inventors regularly introduced new and improved photographic processes, such as the ambrotype and the tintype, but still no practical full-color process.

By the turn of the century the public had grown accustomed to handcolored photo art. Handcolored postcards were produced and sold by the thousands, most created by full-time colorists using stencils and an assembly line mentality. Handcolored posters were also extremely popular.

The first successful color process, the autochrome plate, debuted in 1907. But this process, too, had its drawbacks: it was expensive and required extremely long exposure times. Handcolored black & white photographs remained popular.

After the First World War, the John G. Marshall Co. Ltd. introduced a line of oils specially formulated for handcoloring black & white photographs. These so-called "photo oils" boasted greater translucency than regular artist oils so they wouldn't hide the image being colored. Over the years, other companies got on the photo oil bandwagon, but none could beat Marshall's quality product and creative, specialized marketing campaigns. Marshall's photo oils are still a popular medium used by handcolorists today.

During the early twentieth century the popularity of handcoloring was so great that it was common practice for photographic studios to keep at least one trained handcolorist on staff ready to provide customers with beautiful, custom-colored photo art. Many of these professional handcolorists learned their vocation through correspondence courses.

Then, in April 1935, Kodak's Kodachrome color film hit the retail market forever changing the public's relationship with the handcolored black & white photograph. Through the 1940's and into the 50's handcolorists managed to keep the art and vocation of handcoloring alive thanks to the high cost of color film and to handcoloring's unique, nostalgic appeal. But soon the price of color film dropped and the popularity of the handcolored image waned.

Today's Coloring Methods

Mostly out of sight in the 1960's and 70's, the handcolored black & white photograph returned in the 80's with a bang. Advertising led the way using selective coloring (coloring only a portion of a black & white image) to draw consumer attention to the products they had for sale. Soon handcolored images became the "new look", again popular with photographers and the public alike. Spectacular, modern, eye-catching handcolored photo art started appearing on magazine covers, calendars, greeting cards, and in books and galleries. This time around, handcolorists didn't limit themselves to the traditional coloring media of oils, watercolors and photo oils. They also experimented with contemporary coloring media such as colored pencils, markers and acrylic paints.

Today, the handcolored photograph seems to have found its place. Not a substitute for color photography, not an arcane hobby kept alive by a devout few, twenty-first century handcoloring is a unique and distinctive photographic technique all its own.

"Spectacular, modern, eye-catching handcolored photo art..."

Getting Started

Media and Supplies

It's easy to get started in handcoloring. All you need is a few inexpensive art supplies, a suitable black & white print and you're ready for action!

Coloring Media

The best, most versatile media for handcoloring black & white photographs are the same media that artists use to paint and draw on canvas and paper. These include oil paints and pastels, watercolor paints, colored pencils, markers, acrylics and gouache. Sold at art supply stores, artist coloring media come in all shapes and sizes in hundreds of magnificent colors. When purchasing artist coloring media, brand names to look for include Holbein, Rowney, Pentel, Sakura, Berol and Winsor & Newton. Though photo oils specially formulated for handcoloring photographs are available — and some handcolorists swear by them — you'll find that artist coloring media do everything that photo oils do and more.

Artist coloring media — including oils, watercolors and colored pencils — are the most versatile media for handcoloring black & white photographs.

Purchasing all of the available paints, pastels and pencils at one time can be hard on the pocketbook, so just start with a simple, ten or twelve-piece set of student-grade oil pastels. Oil pastels are versatile, easy to use and inexpensive — a small set costs about ten dollars. As you master the basic pastel techniques, you can add more colors to your palette, step up to higher quality supplies or experiment with other media like paints and pencils. If you feel more comfortable starting with photo-specific coloring media, a five-piece set of Marshall Photo Oils sells for about thirty or forty dollars.

As you scan the shelves at your friendly neighborhood art supply store you'll notice that some coloring media are advertised as "student-grade" and others as "artist-grade." Though student-grade media are less expensive than artist-grade media, their colors are usually not as intense or lightfast. (Lightfastness is a relative measure of the media's resistance to fading when exposed to light.) During the manufacture of student-grade media, expensive pigments like cadmiums are replaced with less-pure pigments, and more fillers are used.

Miscellaneous Supplies

In addition to the coloring media of your choice you'll need a few odds and ends: cotton balls, Q-tips, bamboo skewers and brushes for applying colors; wooden toothpicks for mixing paint; a palette or saucer for holding

• **Use small round brushes for coloring details and large flat brushes for larger areas.**

paint; paper towels for wiping things; a sharpener and fine sandpaper for sculpting pencil tips; and solvent for smoothing and removing colors. Make sure the cotton balls are 100% cotton — synthetic fibers are too coarse. Brushes come in an array of sizes, shapes and fibers. As you might guess, small round brushes are used for coloring details while large flat ones are used for coloring larger areas.

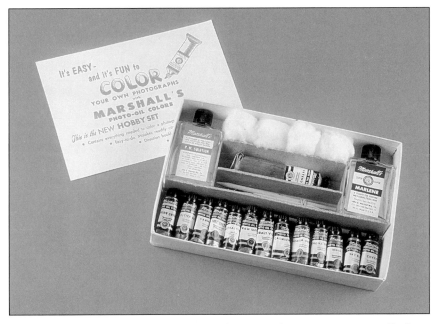

Marshall Photo Oils, available at most photo supply stores, are specially formulated for handcoloring photographs.

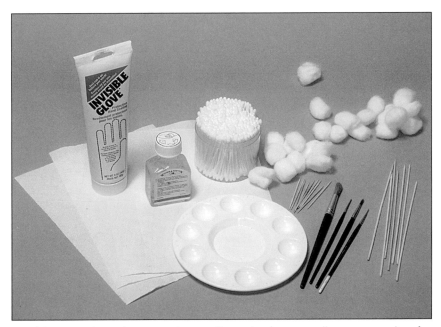

In addition to the coloring media, you'll need a few miscellaneous supplies for mixing, applying and removing color.

One of the main tools for handcoloring a photograph isn't for sale in any store — you make it yourself from a bamboo skewer and a piece of cotton. You'll use the cotton-tipped skewer primarily for detail work.

How to Wrap a Skewer

1 To fashion a cotton-tipped skewer you need a cotton ball, a bamboo skewer and a small amount of water.

2 Moisten the tip of the skewer with the water.

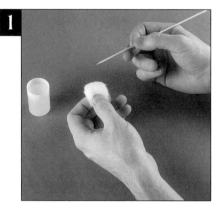

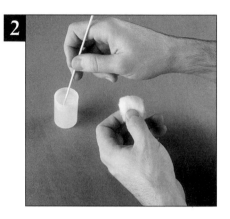

3 Stick the skewer in the cotton so that the fibers encircle it.

4 With your index finger holding the cotton against the skewer, draw off as much cotton as you need. For most applications, a quarter-inch will do.

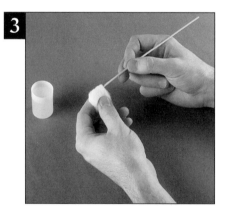

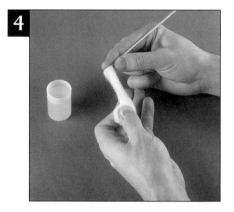

5 Pinch the cotton against the skewer between your thumb and index finger. Then, with your other hand, twirl the skewer wrapping the tip with cotton.

6 The finished applicator should be tightly wrapped, free of loose threads, and the skewer's point should be covered.

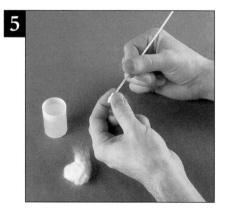

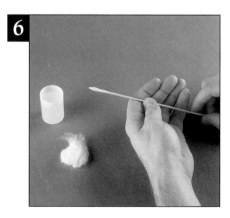

Setting Up Your Workspace

To handcolor photographs you need a flat work surface that's hard and smooth. Drafting tables are ideal because you can adjust the height and incline to the position you find most comfortable. A desk or tabletop will do just fine. However, if you choose to work on your kitchen table be warned that you may end up eating lead chromate, cadmium sulfide or other unappetizing substances found in coloring materials.

Because blemishes on the work surface can be rubbed into the print, it's critical that your work surface is absolutely smooth. If your work surface is a little rough, place a sheet of mat board or acrylic on top. Some colorists like to place the mat board on a painter's easel then color on that.

Whatever work surface you choose, cover it with a clean sheet of untextured paper before each handcoloring session. You'll use the paper to blot excess paint from your coloring tools, clean pencil tips and generally keep from making a mess of the place. Use white paper so you can test colors before applying them to the photograph.

To distinguish the colors you apply, your workspace should be well lit and free of shadows. Painters cherish natural light from a north-facing window, but strong artificial light will do as long as the bulb you're using is daylight balanced, and most are. To avoid casting annoying shadows on your work, position the photograph or light fixture so the light strikes down from the left if you are right-handed. A cautionary note about working in direct sunlight: pastels or crayons may melt, paints may separate, pencils may exhibit "wax bloom" or your photograph may curl. Certain coloring media require the use of solvents like turpentine or mineral spirits, so it's imperative that your workspace is well ventilated. At the very least, work by an open window. To create your best work, you'll need all brain cells intact!

Many professional colorists choose to work on a drafting table because the height and incline are adjustable.

When working on a horizontal surface, use a mahlstick or see-through acrylic bridge to steady your hand and prevent smearing the colors you've applied.

Selecting a Photograph

Beneath the pigment of every stunning handcolored photograph lies an excellent black & white image. When evaluating a photograph's handcoloring promise, place faith in your intuition. Ask yourself: "Do I *like* this black & white photograph? Does it *inspire* me? Does it *excite* me?" If the answer is "yes," give it a try!

Failing "The Intuition Test," you may wish to apply these subjective, academic criteria to the black & white image: Is the subject interesting? Is the composition stimulating? Do all elements in the image work together as a harmonious whole?

• **When choosing a b&w image for handcoloring, consider the level of detail and tonal range of the photo.**

Also consider the photograph's level of detail and tonal range. Once colored, simple images with few objects and tones tend to look flat, two-dimensional. On the other hand, more complicated images with a range of grays tend to look naturalistic. Another point to keep in mind is that the translucent colors usually applied to photographs don't show very well over dark areas. You may wish to leave dark areas uncolored or cover them with an opaque medium like gouache or acrylic paint.

Printing Considerations

Whether you develop the photograph yourself or have a lab do it for you, the image you select for handcoloring must be well printed. That means correct exposure and sharp focus, unless deliberately shot out of focus for effect. Because handcoloring tends to darken the image, some handcolorists like to underexpose their prints by five or ten percent to compensate. In any case, leave at least a 1/8" border on all sides of the print so you can tape it to your work surface without damaging the image.

Paper Type and Finish

The type of paper on which your photograph is printed affects how color will adhere to the image. Generally, color sticks to fiber-based paper better than to resin-coated paper. Also, fiber-based paper takes much, much longer to process, which means you spend longer hours in the darkroom or pay higher costs at the lab.

FINISH

A term used to describe the relative glossiness of the surface of photographic paper. The three standard paper finishes are matte, pearl and glossy.

Another factor to consider is that different brands of paper have different tonal characteristics. As a rule of thumb, Ilford papers are cold-toned (meaning the blacks are slightly bluish) while Kodak and Agfa papers are warm-toned (meaning the blacks are slightly brownish). These tonal characteristics subtly alter the colors you apply on top.

Of the three standard photographic finishes — matte, pearl and glossy — matte accepts color best. Pearl is satisfactory for most handcoloring applications. Avoid glossy: most handcoloring media don't stick. If you're dead set on handcoloring a glossy photograph, treat the surface with a spray-on matte finish such as Krylon Matte Finish or reprint the image on matte paper.

Though fiber-based and resin-coated photographic papers are by far the most common canvases for handcoloring, they're not the only ones you can use. Handcolorists have successfully colored images printed on watercolor paper, linen, colored photographic paper — even Polaroids. Film negatives can also be handcolored.

"Any size print can be handcolored..."

Print Size

Any size of print can be handcolored, but 8" x 10" is the most manageable size. Snapshots printed 4" x 6" or smaller may require the use of special detailing brushes — not to mention superior manual dexterity. Extremely large prints can take forever to handcolor, plus they afford greater opportunity to smudge the work-in-progress.

Choosing a Coloring Medium

Choosing the coloring medium you will use depends partly on the look you want to achieve and partly on your personal inclination. As you flip through the pages of this book, and handcolor a few black & white photographs of your own, you'll develop a sense of the visual qualities the different media impart to an image. For the novice colorist, oil pastels and colored pencils are the easiest media to use with immediately satisfactory results. Once acquainted with all the media used to handcolor photographs, you may elect to use several different media on the same photograph. For instance, you may like the realistic flesh tones of oil paints for coloring people's skin but find it easier to fill in details like eyelashes and beauty marks with colored pencils. (See Appendix B, page 100.)

Securing the Print

To keep the photograph from shifting when you're handcoloring it, tape its corners to your work surface with drafting or masking tape. If you want to keep your borders sharp and clean, run the tape along all four edges. Drafting tape is slightly less sticky than masking tape and less likely to tear the print when you remove it. If you're using masking tape, you can reduce its stickiness by first applying it to your clothing. When working to archival preservation standards, do not stick tape on the photograph. Instead use acid-free photo corners to hold the print in place.

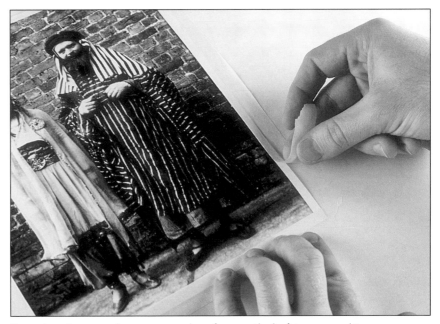

Tape the photograph to your work surface with drafting or masking tape.

When archival preservation of the print is a concern, secure it using acid-free photo corners.

Retouching the Print

Retouch any spots or scratches on your photograph *before* you start hand-coloring. Fill in white spots (caused by dust on the lens or negative) using a small brush (usually size 3/0, 4/0 or 5/0) and spotting dye. Let the photograph dry for at least thirty minutes before handcoloring. On fiber-based paper you can use a knife to scrape away tiny dark spots. If you plan to tone or dye your print before handcoloring it, retouch the print after the toner or dye is applied so you can better match the color.

• **Before handcoloring, retouch any spots or scratches on your photo.**

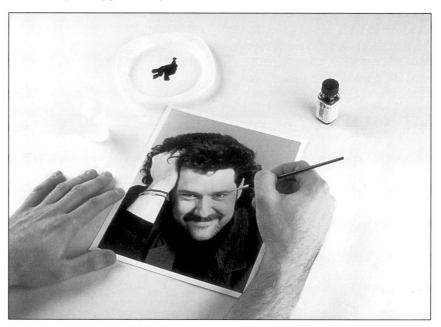

Spot the photograph to hide any flaws before handcoloring it.

Protecting the Work-in-Progress

Depending on the complexity of the image and the way you choose to color it, you may not be able to complete the photograph in one sitting. To protect your work-in-progress from collecting dust or dirt, cover it with paper towel, tissue or wax paper.

Between coloring sessions, cover your work-in-progress with paper towel.

A Word About Safety

Unfortunately many of the best materials for handcoloring photographs can, if not properly handled, be dangerous to us or our environment. Here are a few things you need to know to use coloring materials safely.

• Read and follow manufacturers' instructions and safety directions on all materials used for handcoloring photographs.

- Don't eat, drink or smoke while coloring and don't hold brushes or pencils in your mouth. You could ingest toxic substances.
- Never use your fingers to apply or blend colors. Bandage any cuts on your hands before you start.
- Use odorless mineral spirits instead of turpentine or similar solvents. When using solvents, wear protective gloves or barrier cream. Replace lid immediately after use. Keep your workspace well ventilated. Solvents are flammable; store them appropriately.
- Keep toxic supplies and contaminated garbage away from children and pets.
- To clean your hands, use baby oil, vegetable oil, soap and water or a non-toxic, waterless hand cleaner. Never use solvents.
- When toning, dyeing or bleaching photos, wear gloves and goggles. Use tongs to handle prints. Avoid toning during pregnancy.
- Read product labels, instructions, and safety data sheets for warnings and instructions on how to use and store materials safely.
- Dispose of chemicals and hazardous waste according to your region's environmental regulations.

Toners & Dyes

"Toning or dyeing...can help you achieve a better handcolored result."

Introduction

Before settling in to handcolor your black & white photograph, think about toning or dyeing it first. Toning or dyeing changes the base color of the print, which can help you achieve a better handcolored result. One popular practice is toning portraits sepia (yellowish brown) to make the subject's skin coloration look more natural.

Some handcolorists like to experiment with a variety of toning or dyeing techniques just to see what unique after-coloring results they can come up with. If you choose to tone or dye your photograph, keep in mind that the base tone affects all colors you apply on top. For instance, on a sepia-toned print, blues will look slightly greenish. You may want to mask white areas such as eyes and teeth first.

Toners

Toners work by chemical reaction, replacing silver in the print's emulsion with another metal such as iron or gold. The reaction causes subtle changes in tone and contrast. Because of the greater silver content, dark areas (objects and shadows) tone more dramatically than light areas (background and highlights).

Not only can toning enhance the esthetics of an image, it also can improve the archival stability of the print. Photographs toned with gold or selenium resist degradation better than ordinary silver-emulsion black & white photographs. Some photographers tone strictly for the archival benefits.

Berg, Kodak and Agfa manufacture sepia, blue, gold, copper, brown, selenium and other toners in liquid and powder form. Though liquid toners are more expensive than powders, they're easier and safer to use. Because toners work by chemical reaction, the physical color of the toner doesn't always match the color the print will be toned.

Berg, Kodak and Agfa manufacture toners in liquid and powder form.

Dyes

Unlike toners, which work by chemical reaction, dyes add color to a print by staining the gelatin layer, sinking into the print's emulsion. By immersing a print in a dye bath you can color it red, yellow, orange, green or other

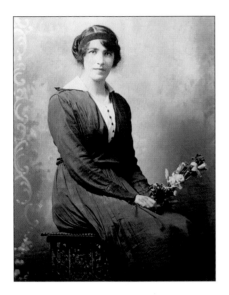

The portrait below was sepia-toned before handcoloring; the photo on the left was not. Notice the richer, more realistic skin tones on the sepia-toned print. Both portraits were handcolored using Winsor & Newton oil paints. (Photographer unknown.)

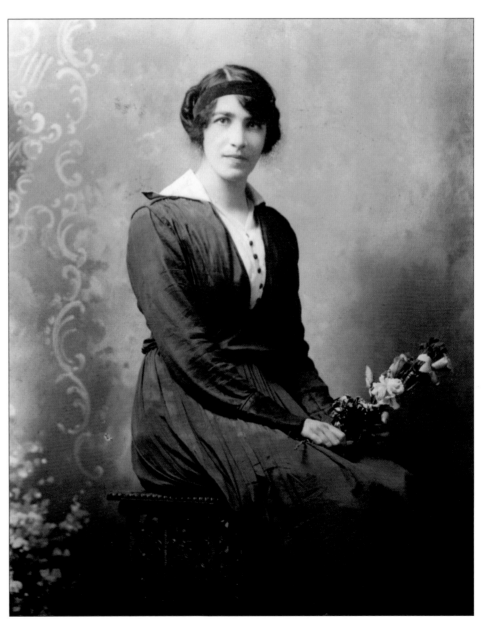

bright colors. Unlike toners, dyes do nothing to protect the photograph's surface and fade relatively quickly, particularly when exposed to direct sunlight.

Berg manufactures dyes specifically designed for use on photographs. Sometimes called mordant dyes, Berg dyes employ an activator to chemically alter the silver on the emulsion so the dyes will adhere to it.

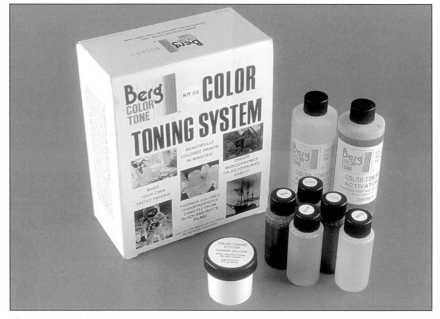

The Berg Color Toning System lets you dye photos an array of bright colors.

Print Considerations

Certain toners work better with certain papers. For instance, sepia toners produce especially dark, dramatic results on warm-toned Kodak papers. Though you can tone either fiber-based or resin-coated prints, fiber-based prints take much longer to process because of the lengthy washing cycles they require. Dyes work equally well on fiber-based and resin-coated prints and look especially brilliant on glossy finishes.

General Procedure

Ideally, toning or dyeing should be performed in a darkroom (with the lights on). It's possible to tone or dye in the bathroom, but keep in mind that the solutions may stain your sink or tub. The general procedure is to soak the print in hypo eliminator solution, bleach or activate the print (if necessary), immerse the print in the toner or dye solution, then wash and dry the print. Detailed procedures vary from product to product, so always check the package for specific instructions as well as important safety precautions.

While dyeing yields reasonably consistent results, toning is somewhat less predictable. The nature and degree of toning depends on the photographic paper, the tonal contrast of the image, the dilution of the toning solution, the time of immersion in the toning solution, even — believe it or not —

HYPO ELIMINATOR SOLUTION

A washing aid that removes residual fixer from photographic paper or film before the final wash. Helps prevent staining and deterioration of the paper or film.

Toning and Dyeing Procedure

1 To sepia-tone a black and white print, immerse it in hypo eliminator solution. Slide the print in from the edge so it quickly submerges.

2 Using tongs, transfer the print to the wash tray. Wash the print. Fiber-based prints require much longer washing cycles than resin-coated prints.

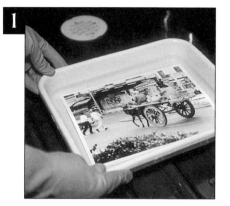
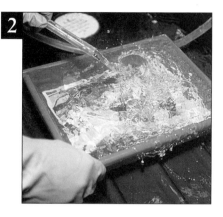

3 Bleach the print until the image almost disappears.

4 Wash again.

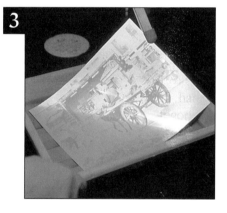
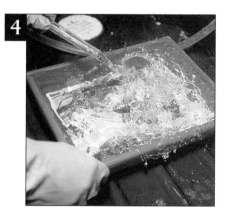

5 Immerse the print in the sepia toning solution. Keep it submerged. Rock the tray so the print tones evenly.

6 Wash the print one last time and then dry the toned print. If you don't have a print dryer or a drying rack, hang your print to dry like laundry on a clothesline.

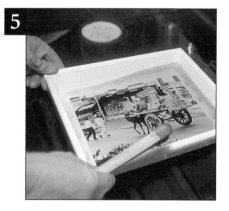
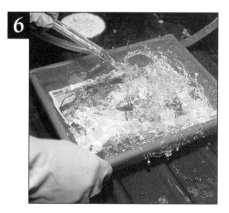

Toning

This b&w photograph is printed on Ilford Multigrade IV RC Deluxe photographic paper, pearl finish.

Sepia-toned using Berg Rapid RC/Sepia Toning Solution.

Golden/yellow-toned using Berg Golden/ Yellow Toning Solution.

Brown/copper-toned using Berg Brown/ Copper Toning Solution.

Selenium-toned using Berg Selenium Protective Solution.

Blue-toned using Berg Brilliant Blue Toning Solution.

Dyeing

Dyed yellow using the Berg Color Toning System. This image is printed on Ilford Multigrade IV Deluxe RC paper, pearl finish.

Dyed using Berg Green.

Dyed using Berg Blue 2.

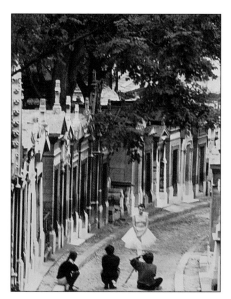

Dyed using Berg Blue 1.

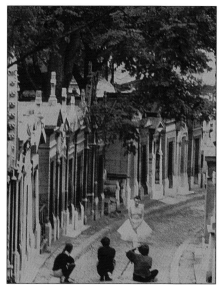

Dyed using Berg Red 2.

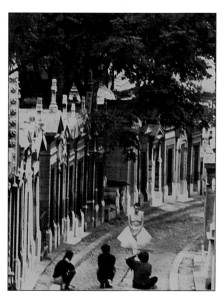

Dyed using Berg Violet.

the age, temperature and strength of the developer used to develop the print. Some photographers keep detailed records of how they tone each print so they'll have a better chance of duplicating results they like.

In the Darkroom

When processing prints for toning or dyeing, always use fresh developer and fixer, and fix to the optimum fixing time specified by the manufacturer. Avoid hardening fixers — they inhibit toning.

Setting Up

Most toners and dyes aren't light sensitive so you don't need to work in the dark. When toning or dyeing, wear gloves and goggles, use plastic tongs to transfer the print between solutions and work in a well ventilated area. Toners and dyes will stain clothing.

To start, you'll need three clean plastic photo trays (photo trays are grooved so liquid can flow around the print preventing it from sticking to the bottom). Fill one tray with a diluted hypo eliminator solution such as Kodak Hypo Clearing Agent. Hypo eliminator is a washing aid that helps remove residual fixer and reduce washing time.

In the next tray, mix the toning solution or dye bath, whichever you are using. Use the third tray for print washing. When sepia-toning or using mordant dyes, you'll need a fourth tray for bleaching or activating the print.

Washing the Print

Before toning or dyeing, wash the print thoroughly to remove residual silver compounds and to wet the print for an even application.

Soak the print in the hypo eliminator solution for 2 minutes if the print is resin-coated, 30 minutes if fiber-based. Transfer the print to the washing tray and wash for the same duration.

"Toners and dyes will stain clothing."

Uneven toning and staining usually indicates that the print was not washed thoroughly.

Bleaching or Activating the Print

Some toners — Berg's sepia for one — require that the print be bleached before toning. If bleaching is required, the bleach will be supplied with the toner.

Immerse the print in the bleach solution for 1 or 2 minutes until the image has almost disappeared. Then wash the print for 2 minutes if resin-coated, 30 minutes if fiber-based. Mordant dyes require soaking the print in an activating bath before dyeing. Soak resin-coated prints for 1 minute, fiber-based prints for 5 minutes. Then wash the print for the same duration. If you skip the activation step, shadows and highlights will color evenly.

Immersing the Print

After washing, remove the print from the wash tray, then quickly immerse it in the toning solution, image-side up. Soak the print for the time recommended in the product instructions, rocking the tray periodically to keep the print completely submerged.

Generally, resin-coated prints fully tone in 1 to 2 minutes, fiber-based prints in 5 to 10 minutes. You may wish to run a test strip before toning or dyeing the actual print.

Final Wash

From the toning or dyeing solution, immediately transfer the print to the wash tray. Again, wash the print for 5 minutes if resin-coated, at least 30 minutes if fiber-based. Hang the print to dry or place it in a print dryer set to air only, no heat.

Reversing the Process

If you're not entirely satisfied with the toned photograph, you may be able to reverse the process and reclaim the original black & white image by washing or bleaching the print. Success will vary with the type of toner used. In some cases you can use a different toner directly without first returning to black & white. Again, check your product instructions for details.

Dye, too, can be removed if you wash the print long enough. Too much washing, however, will destroy the paper. The Berg Color Toning System includes a special clearing solution that can be used to remove dye from highlights while leaving dark areas intact.

Selective Toning or Dyeing

Sometimes you may wish to tone or dye only a portion of a print rather than the whole thing. To tone or dye select areas of a print, mask the print before immersing it in the toner or dye.

The easiest way to mask small areas like eyes or teeth is using masking fluid such as Winsor & Newton's Art Masking Fluid. Paint the masking fluid on using a brush. After the masking fluid dries, which should take only a few minutes, you can tone or dye the print. Take care not to flex the masked print and crack the mask. Once the toning or dyeing is complete, simply peel away the mask.

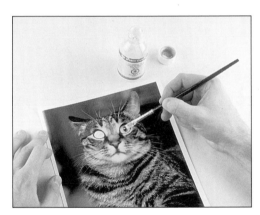

Use masking fluid to mask small areas.

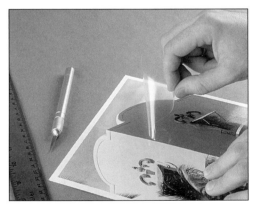

Frisket paper masks large areas effectively.

This image was dyed in red wine.

These four resin-coated test strips were immersed in Berg Red #1 dye for different lengths of time. From left to right: 30 seconds, 1 minute, 3 minutes, and 5 minutes.

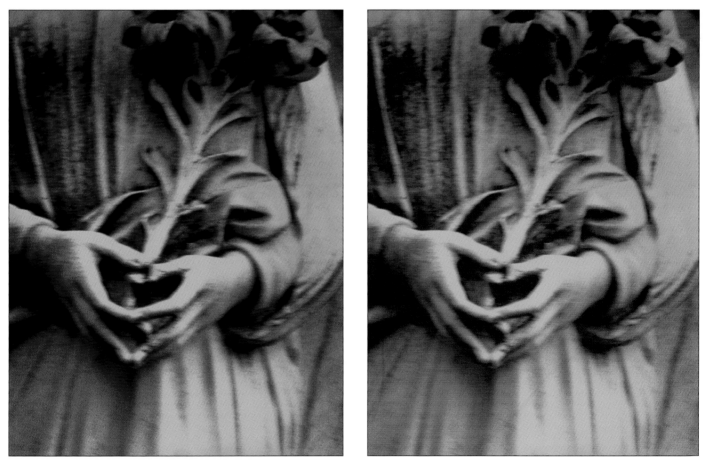

The print on the left was activated before dyeing; the print on the right was not. Note how activation causes the dye to be attracted to dark areas.

To mask large areas like backgrounds, frisket paper is the best choice. Stick the paper onto the print then use an X-acto knife to score the outline of the area you want masked. Take care not to cut into the photo beneath.

Peel away the frisket paper to expose the area to be toned or dyed. If you find yourself masking nearly the entire print, it may be easier to forget about masking and paint on the toner or dye with a brush or cotton swab instead.

Special Techniques

By shunning the standard textbook toning methods, it's possible to produce an array of out-of-the-ordinary visual effects. For instance, you can try exceeding recommended toning times, partially reversing the toning process or toning in one solution then another. One common practice is called split toning. Split toning is the same as selenium toning, except you leave the print in the solution for a longer duration, usually at elevated temperature. By doing this, shadows darken, a range of tones appear and the image gains a three-dimensional quality.

• **Organic dyes such as tea or red wine may cause a print to deteriorate rapidly.**

Rebels forsaking tried and true prepackaged photographic dye methods may wish to experiment with unorthodox dyes such as food or fabric dyes — even tea or red wine. But be warned: organic dyes may cause rapid print deterioration.

Storing Toners and Dyes

Most toners and dyes can be reused several times. Once mixed, they have a shelf life of about six months, if stored in airtight, opaque containers. Check the product specifications to find out the maximum toning or dyeing capacity, and keep track of how many times you use each solution. Store toners and dyes away from children and pets, heat and flame.

Oil Paints & Pastels

Paints and pastels are the most practical, versatile oil-based media for handcoloring photographs.

Introduction

Oil paints, pastels and photo oils are the most widely used media for adding realistic color to black & white photographs — especially portraits. You'll find their rich, smooth colors easy to apply and, in the event of a coloring blunder, easy to remove. Oil-based media are highly resistant to fading so your handcolored artworks can be enjoyed for years to come.

Oil Paints

Packaged in tubes, oil paints consist of finely ground pigments bound with drying oils such as linseed or poppy oil. Most oil paints are only semi-transparent so you may need to mix in transparentizing gel to increase their transparency. The degree of transparency varies from brand to brand as well as from color to color. For instance, cadmiums and cobalts are usually less transparent than most earth colors. Holbein, Rowney and Winsor & Newton manufacture student and artist-grade oil paints that are excellent for handcoloring black & white photographs.

Marshall Photo Oils

Marshall Photo Oils are much like artist oil paints, just thinner in consistency and maybe a touch less bright. When you purchase a set of Marshall Photo Oils you'll also receive a solvent solution for preparing the print (called Prepared Medium Solution), a thinning gel (called Extender) and a solution for removing mistakes (called Marlene). For high-impact images, Marshall offers a line of Extra Strong colors. They also sell photo pencils color-matched to their photo oils. These pencils are intended for detail work on Marshall-colored photographs.

Straight out of the tube, photo oils (right) are thinner in consistency than artist oil paints.

Oil Pastels

Oil pastels are really just oil paints thickened with binders then extruded into easy-to-handle sticks. Don't confuse oil pastels with the soft chalk pastels commonly used by artists — chalk pastels won't stick to photographic paper. Manufacturers of oil pastels include Sennelier, Holbein, Pentel and Sakura.

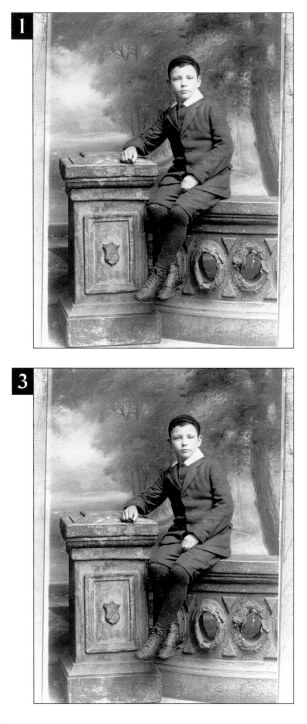

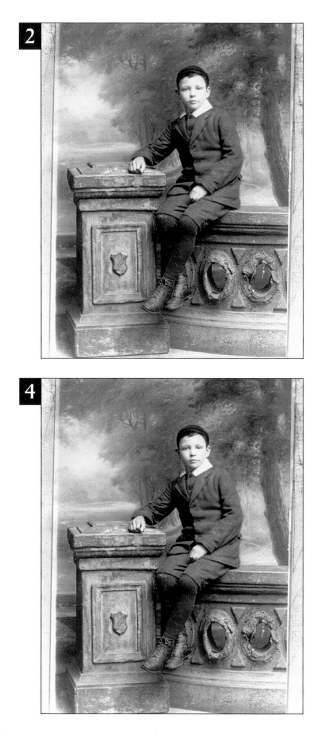

1 "Great Uncle Neil" is a studio portrait from the 1890's. (Photographer unknown.) To preserve the original photograph, a large-format copy negative was shot, then a resin-coated print was developed for handcoloring. Before coloring, the newly printed copy was sepia-toned to: 1) improve the skin tone and 2) give the print an old fashioned flavor.

2 After preparing a palette of Marshall Photo Oils, the suit and cap were colored Sepia. After clearing away color accidentally slopped onto the collar, Cadmium Yellow was added to the buttons to simulate brass. A bit of Sky Blue was applied to the boots.

3 The face and hands were colored with a dab of Flesh on a cotton-tipped skewer. To bring his complexion to life, hints of Cheek were applied on his lips, forehead and cheeks. The hair was colored Verona Brown and eyes Sky Blue.

4 Next, the ground on the backdrop was colored Raw Sienna, with hints of Sepia and Verona Brown applied and blended with a Q-tip. The same colors were used for the tree trunks, but instead of applying them with a Q-tip, a cotton-tipped skewer was used. The sky was then colored using a Q-tip loaded with Sky Blue.

5

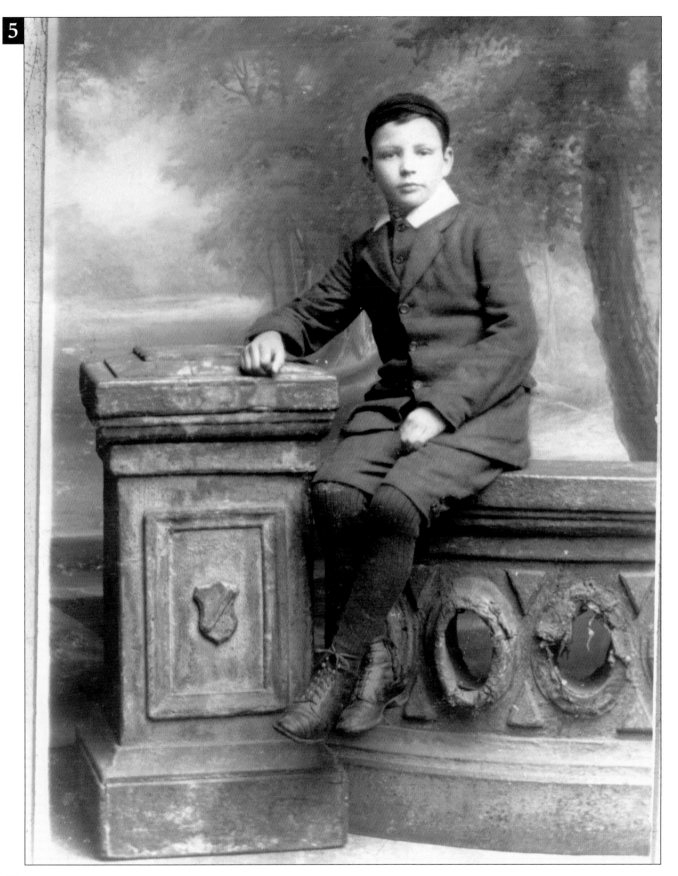

5 To complete the image, two shades of green were washed over the tree leaves: Tree Green and Oxide Green. Although Marshall Photo Oils were used to color this portrait, a similar result could have been achieved using artist oil paints.

"Store pastels in their original container…"

Store pastels in their original container or, if buying pastels singly, invest in a pastel box. Oil pastels aren't quite as fragile as chalk pastels but may break when dropped. When using wrapperless pastels like those made by Holbein, attach a pastel holder to keep toxic pigments off your hands.

Metallic oil pastels can be used to add highlights and create special effects.

Other Oil-Based Media

In addition to paints, pastels and photo oils, other oil-based media include crayons, bars, sticks and pencils. Oil crayons, such as those made by Caran d'Ache, are similar to oil pastels except the pigments are held together by wax. The wax makes them somewhat opaque and gives them a heavy texture. Oil bars and sticks are larger and slightly stickier than pastels. Oil pencils are just thin, wood-encased pastels.

Wax-oil crayons are great for building textures.

An oil bar is a large, sticky oil pastel.

Which Oil-Based Medium Works Best?

Deciding which oil-based medium to use depends on the size of the area you want to color and the effect you want to create.

- Tube paints are easily applied in smooth washes, which makes them a practical choice for coloring large areas like oceans, skies and backgrounds.

- Oil pastels are easier to handle than tube paints, but their colors are more difficult to blend to a smooth finish.

- Oil crayons are waxy and opaque, which makes them good for building textures.

- Oil bars and sticks are very similar to pastels, but their large size makes them somewhat unwieldy.

- Oil pencils are good for coloring small, intricate details.

All oil-based media dissolve in mineral spirits so you can mix and match, using any or all oil-based media on the same photograph with no special considerations.

Preparing the Print

"...it's a good idea to coat the print with mineral spirits."

Applied directly to a naked print, oil-based colors grip the print's surface a little too strongly. So before you start coloring, it's a good idea to coat the print with mineral spirits.

Using a cotton ball or Q-tip, apply just enough mineral spirits to moisten the area you plan to color. Blot off any drops or puddles of mineral spirits with a paper towel. Blotting is particularly important when using resin-coated paper which repels liquid; fiber-based paper soaks up the mineral spirits quite nicely. If you're using Marshall Photo Oils, substitute Prepared Medium Solution for mineral spirits.

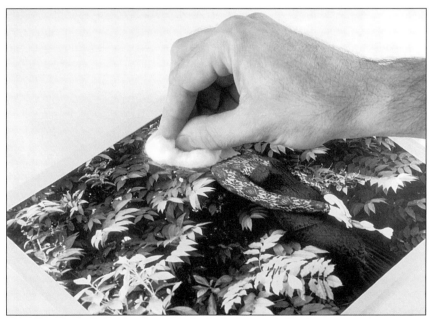

A light coat of mineral spirits on the surface helps color go on smoothly.

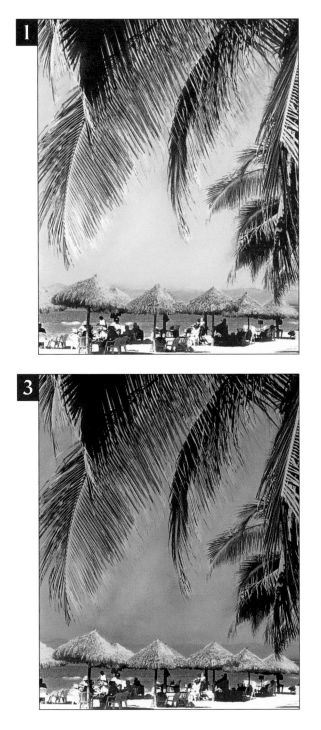

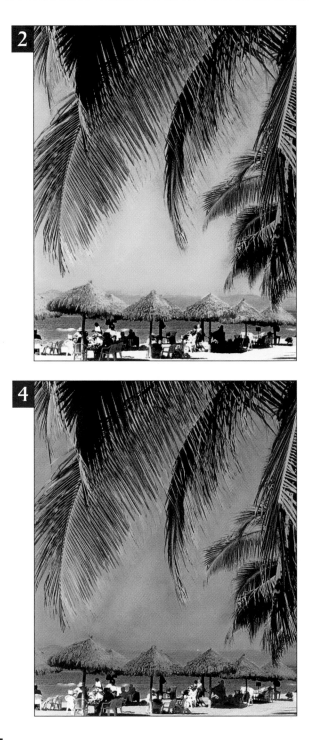

1 "Tropicana" is printed on Ilford Multigrade fiber-based paper, matte finish.

2 After preparing a palette of transparentized Winsor & Newton oil paints of tropical colors, a light coat of mineral spirits was applied to the photograph to smooth the color application. Using a cotton-tipped skewer, three colors of paint were applied to the palm branches in the foreground: Cadmium Green on the leaves, Terre Verte in the shadows and Light Green in the highlights.

3 Though this photo was taken on an overcast day, the artist decided to make it sunny to better suit the tropical scene. Cerulean Blue mixed with Titanium White was applied to the sky using a Q-tip and smoothed with a cotton ball. The mountains were colored Cobalt Violet and the water Ultramarine Blue.

4 Next, the umbrellas were colored Burnt Sienna with hints of Vandyke Brown in the shadows. The poles supporting the umbrellas were also colored Vandyke Brown and the sand was colored Yellow Ochre.

5 The people and chairs were colored with a cotton-tipped skewer using Rose Magenta, Chrome Yellow and Orange. The intensity of the colors was varied by layering. One final touch: a hint of thick Titanium White (no transparentizing gel mixed in) where the waves foam.

The main tools for applying oil paints and photo oils.

"Experiment with each of the coloring tools."

Preparing Your Palette

When using oil paints or photo oils, use a palette to hold and mix colors. Of course, you don't need a palette for pastels or crayons — you apply them directly to the photograph.

When you're ready to color, squirt a small blob of each color you plan to use onto the palette. Using a toothpick, mix in about an equal amount of transparentizing gel (Grumbacher's is one popular brand) into each blob. Transparentizing gel increases the paint's translucency without significantly reducing its color strength. On those occasions when thicker, more opaque color is what you're after, don't use transparentizing gel at all.

Photo oils are formulated to be translucent so they don't need to thinned, but if you wish you can mix in a little Extender to soften the colors.

Applying the Color

After preparing the photo's surface and choosing your colors, you're ready to start handcoloring. To apply paint or photo oils you can use any or all of the four main color application tools: a cotton ball, a Q-tip, a cotton-tipped skewer or a brush. Cotton gives a smooth wash of color while brushes leave obvious brush strokes.

For detail work, a cotton-tipped skewer or a small brush works best. Normally you'll use a fresh applicator or clean brush for each color. Experiment with each of the coloring tools. You'll soon discover their individual strengths and weaknesses.

When using artist oil paints, squirt the paint onto the palette, then mix in transparentizing gel to increase its translucency. Photo oils don't need to be thinned — they're ready to go.

Applying Paints

1 Paint large areas using a cotton ball or Q-tip.

2 Color details with a cotton-tipped skewer or brush.

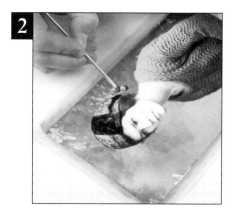

Applying Pastels

1 Clean your pastel before use.

2 When using pastels, color directly on the photograph.

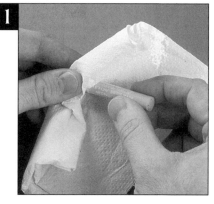

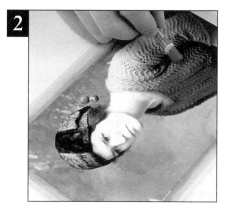

3 After applying the color, smooth away any blotches by gently rubbing the surface with a cotton ball.

4 When the area is too small to color directly with a pastel, use a cotton-tipped skewer to transfer pigment from the pastel to the photograph.

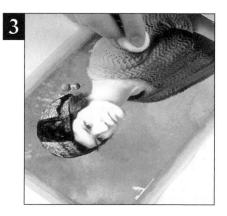

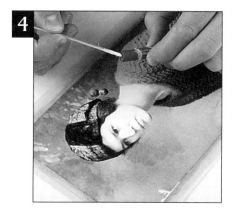

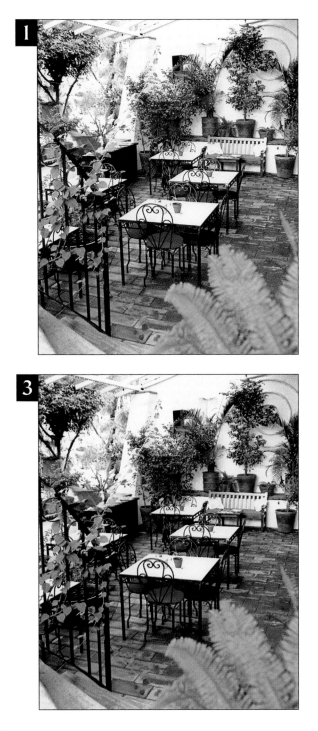

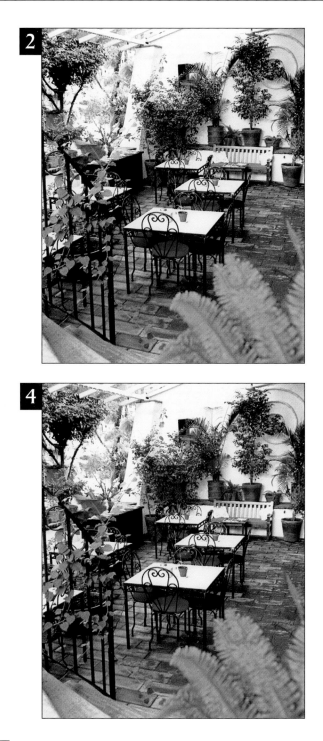

1 "Cafe" is a simple interior suggesting quiet and anticipation. The artist's initial response was to selectively color the image for a moody, contemporary look.

2 The seats of the chairs were colored using a cotton-tipped skewer and a Carmine Caran d'Ache Neopastel. It took several applications to build up the color to the intensity you see here. Notice that a few of the chairs are too black to color with this transparent medium so they were left as is.

3 Switching from pastels to Marshall Photo Oils, the clay pots were colored Cadmium Orange using a Q-tip for the larger pots, a cotton-tipped skewer for the smaller ones. It's perfectly acceptable to use more than one type of oil-based media on the same photograph. The important thing is that the color is right.

4 Sticking with Marshall's, the greenery was colored Jade Green using a skewer. For visual complexity, touches of Tree Green were added to the shadows.

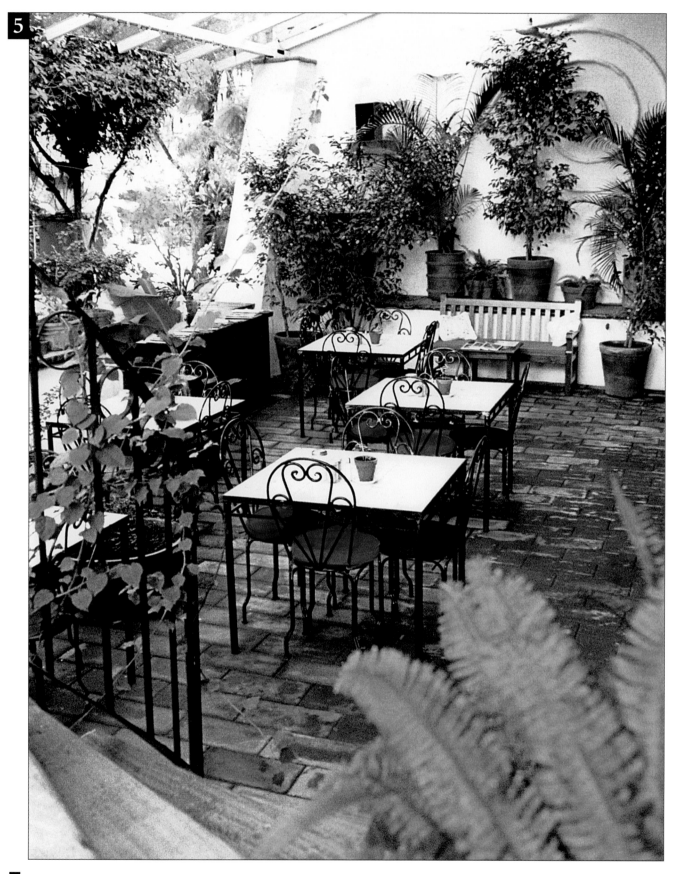

5 Another layer of color was added to the greenery to increase the color intensity. Marshall's Cadmium Orange was applied on a few bricks. Finally, switching media one last time, hints of Chrome Yellow Rowney Georgian oil paint were dotted onto the fairy lights using a cotton-tipped skewer.

• **Pastels build up fast so go easy on the color.**

When coloring with a pastel, stroke the color onto the photograph then smooth the application using a cotton ball or Q-tip. For detail work, transfer the pigment from the pastel to the print using a cotton-tipped skewer dipped in mineral spirits. Go easy on the color — pastels build up fast. This application method also works for oil crayons, bars and sticks.

Many first-time colorists are surprised at how blotchy oil colors look when they're first applied. Not to worry. Take a cotton ball and smooth out the color to an even, professional finish. Don't be concerned if the color seems a little weak. You can build the intensity later by layering more color on top.

Overlapping

EDGE HALO

Ridges of color between objects on a handcolored photo. Caused by failure to overlap color.

Handcoloring a photograph isn't like coloring a paint-by-numbers — you don't always get the best results by staying within the lines. Overlapping colors just slightly helps produce a smoother, more natural finish. Failure to overlap leaves definite ridges of color between objects, sometimes called "edge halo." Edge halo robs your image of depth and polish.

Color Washing

Color washing is an extreme form of overlapping and a good way to color landscapes and backgrounds. When coloring an oak tree, for instance, it's not necessary to color each leaf in the tree individually. Instead use a cotton ball to apply a wash of green over all the leaves. Not only is color washing quick and easy, but it gives the image a more natural appearance.

There's no need to color each leaf on the side of this building individually. Simply blend the color over the area and the highlights and shadows will take care of themselves.

Layering

Depending on the type of paper, its finish and the media you're using, the first layer of color you apply may not be as intense as you would like. To build up the intensity, apply additional layers of color over top, letting each

To clean your brush, wipe away excess paint on scrap paper or newspaper, soak the brush in mineral spirits, then wipe it with a rag.

layer dry between applications. Keep in mind, though, that oil-based media aren't the most intense of the handcoloring media. For super-bright color, you're better off using brilliant watercolors or markers.

Adding Highlights

It's the little things that really bring your photo to life: a touch of light reflected on the hair or cheek, a sparkle in the eye. Often these highlights get covered up while applying and overlapping color. To restore highlights, dip a cotton-tipped skewer in mineral spirits and wipe away the unwanted color. Another way to restore highlights is by painting in touches of white or very light hues.

Creating Textures

Using pastels or crayons, you can add texture to the surface of your photograph. These thickly applied dots or ridges will catch the light causing the image to twinkle and shimmer. Another texturing technique that can create especially striking results is called optical mixing. By dotting objects in varied colors you create the illusion of mixed color while adding depth to the object.

Mixing Colors

Even with hundreds of colors available you won't always find the exact color you need ready to use from a tube, so you need to mix paints to get the color that your eye tells you is right. Mix paints on the palette using a toothpick. Because it's difficult to mix the same color twice, it's wise to mix more than you need, in case you want to use that color elsewhere on the photograph. A second, less precise way to mix colors is by dipping a Q-tip in one color, then another, then onto the photograph. It's possible to mix colors from solid pastels, too. Do this directly on the photograph by adding a little of one color then a little of another color then blending with a cotton-tipped skewer or Q-tip.

"Mix paints on the palette using a toothpick."

Use a toothpick to mix paints or photo oils.

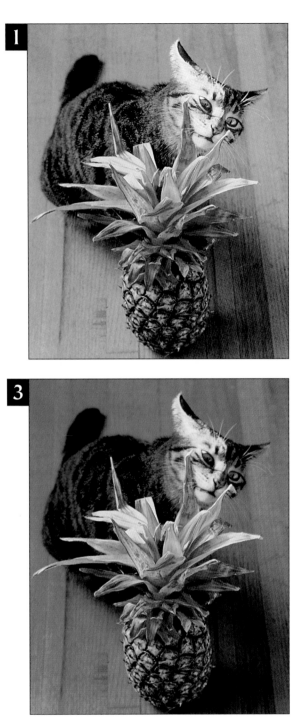

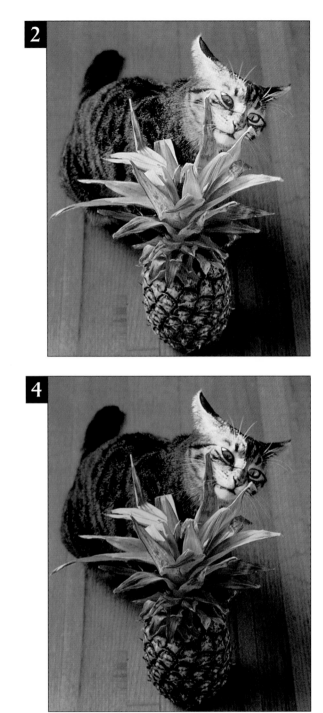

1 Cats are notoriously difficult to photograph because their curiosity draws them to the camera. Here a simple photogenic prop, a pineapple, was used to keep the cat busy.

2 After lightly coating the print's surface with mineral spirits, a cotton ball was used to apply a faint coat of brown oil paint to warm up the color of the hardwood floor. The same effect could have been achieved by masking and toning the print, however that would have been much more time consuming.

3 Turning attention to the cat, a few strokes of a Caran d'Ache Violet pastel were applied to the body, then smoothed using a

Q-tip. To add depth, a second shade of purple, Lilac, was mixed in. The cat's nose was too small to color with a pastel directly, so a cotton-tipped skewer was used to transfer color from the tip of the pastel to the photo. With a fresh skewer, the cat's eyes were colored green. Hints of white were then added where the light reflects in the iris.

4 Several shades of green were applied to the pineapple leaves: Moss Green, Olive, Yellow Green and Light Olive. The pineapple was colored Russet Brown with Umber in the shadows. Applying several shades of color is commonly used in handcoloring to add three-dimensionality and depth to an image.

5

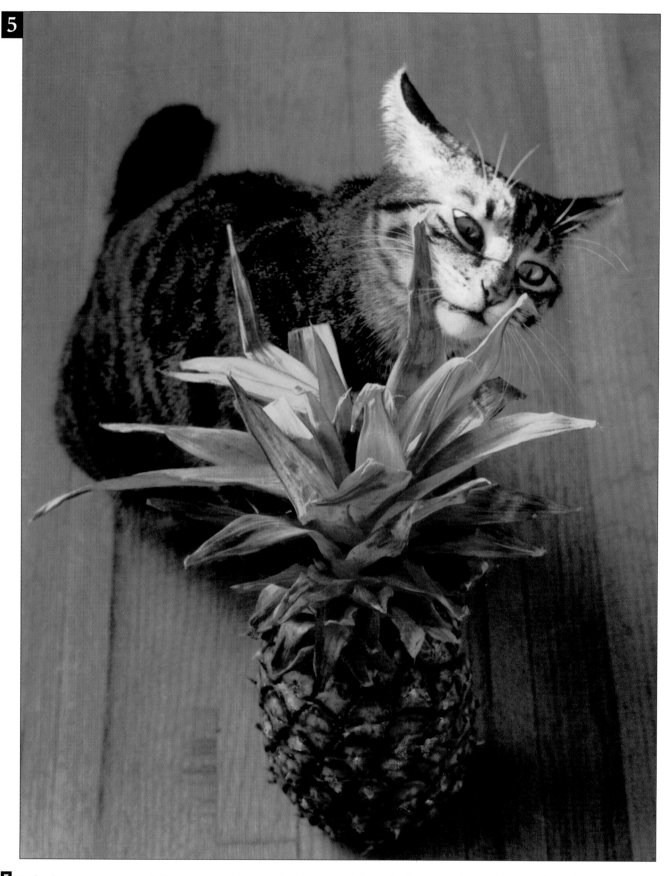

5 To finish up, a cotton-tipped skewer was used to transfer dots of metallic color from Sennelier metallic pastels to the pineapple. Applying these oils in this way creates a raised layer of pigment on the photo's surface which enhances the metallic effect. As a general rule, avoid smoothing metallic colors: it causes them to lose their shine.

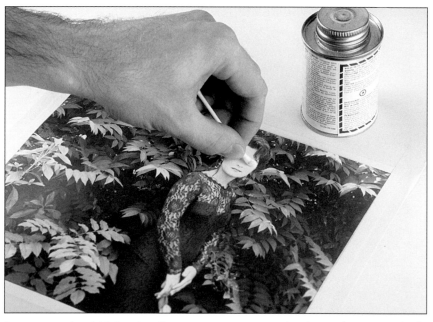

Removing color: While it's still wet, remove unwanted color with a cotton ball or Q-tip dipped in mineral spirits.

"Try not to remove color too many times..."

Removing Color

One of the best things about working with oil-based media is that the colors are easy to remove. You can try one color on your photograph and if you don't like it, replace it with another. Sometimes you may wish to only partly remove a color to lighten it or to create a gradation of color over an area. Gently rub away unwanted color with a cotton ball or Q-tip dipped in mineral spirits. Try not to remove color too many times: you risk exhausting the paper's ability to hold color. Some colors, such as reds and violets, are more stubborn than others and may leave permanent stains.

Save unused paint for the next coloring session by sealing your palette in a Ziploc bag.

Drying Time

Oil-based media are relatively slow drying. So after your handcolored masterpiece is complete, cover it with tissue or wax paper then set it aside for at least 48 hours. Actual drying time depends in part on how heavily you've applied the colors; thick, layered applications may take weeks to dry completely. If you're thinking about using a blow dryer to speed the drying process, consider this: heat may crack the paint and distort the colors you've so lovingly applied. It's possible to speed the drying of oil paints by mixing in specially formulated driers before you color. Driers reduce drying time considerably by attracting oxygen to the paint surface. The Marshall company supplies their own drying product, cleverly dubbed "Drier."

Watercolors

Introduction

Watercolors are a wonderfully versatile handcoloring medium valued for their delicate, luminous, translucent washes of color. If you don't like the smell of solvents or oil-based media, watercolors may be for you: the only solvent needed for diluting, thinning or cleaning watercolors is ordinary tap water. Watercolors are especially well suited to handcoloring nature photographs, landscapes and still lifes.

"Watercolors are a wonderfully versatile handcoloring medium..."

• You can buy watercolors in tubes, or as dry or semi-moist cakes.

Watercolor Paint

Watercolor paint is sold in tubes, or as dry or semi-moist cakes. Tube watercolors have nearly the same consistency as tube oil paints. Cake watercolors are usually sold in pans of 10 or 20 colors. Of the two choices, you're probably better off with tube paints. Cake watercolors are not as rich and they're hard on brushes. When you set out to buy watercolor paints, three brand names to look for are Winsor & Newton, Rowney and Holbein.

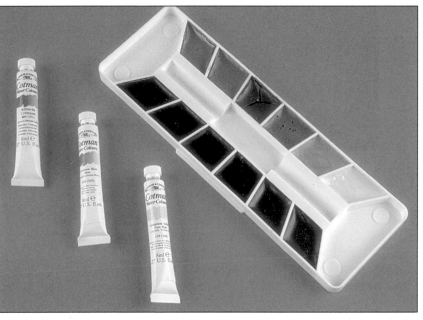

Watercolor paints come in tubes or as cakes.

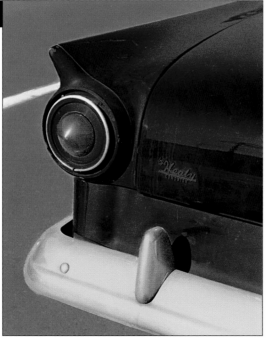

1 This image was printed on resin-coated paper. The car was a rust brown color.

2 No medium is more eye-catching than Winsor & Newton Brilliant Watercolour and that's what was chosen to color this photograph. To keep the lines crisp, the car was first masked with frisket paper. Then three layers of slightly diluted Process Cyan were applied using a cotton ball.

3 The frisket paper was removed and the color that was just applied was given a few minutes to dry. The photograph was then masked again for the next application. This time three layers of Process Magenta were carefully applied to the body of the car.

4 After again masking portions of the photograph with frisket paper, three layers of Process Yellow were applied to the bumper using a Q-tip. You can see how transparent brilliant watercolors are by the way the highlights and shadows shine through. Graphic designers may also recognize the colors used in this image as three-fourths of the CMYK process printing colors.

1 "Starfish" is printed on resin-coated paper, matte finish.

2 Caran d'Ache Neocolor II Aquarelle water-soluble crayons were used to color this photograph. These crayons were chosen for three reasons: the colors are bright, the wax binder leaves a visible texture and, best of all, the crayons are extremely easy to use. The sand was colored with an Ochre 035 crayon, then the area was lightly blended with a slightly moist cotton ball to remove any unsightly blotches and clumps of wax. Next, using that same Ochre crayon and Umber 049, lines and patches of texture were added.

3 The water was colored with two different crayons: Light Olive 245 in the highlights and Olive 249 in the shadows. Again the application was smoothed with a cotton ball.

4 The starfish was colored with Raspberry Red 270, then the application was smoothed with a damp Q-tip. For a finishing touch, a few dots of Ruby Red 280 were added using a 5/0 brush.

"...these modern watercolors yield fantastically brilliant colors."

Liquid Watercolors

Liquid watercolors are an exceptional handcoloring medium. Intended primarily for graphic arts use, these modern watercolors yield fantastically brilliant colors. If you like contemporary art and design, you'll love liquid watercolors! On the downside, they're difficult to remove and fade relatively quickly.

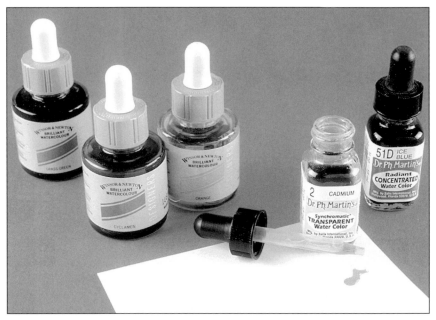

Winsor & Newton Brilliant Watercolour and Dr. Ph. Martin's Radiant Watercolors are exceptional handcoloring media.

Water-Soluble Pencils and Crayons

Two related media at your disposal are water-soluble pencils (such as Staedtler's Aquarelle Pencils) and crayons (like Caran d'Ache's Neocolors).

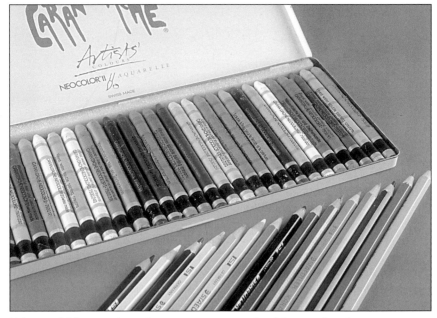

Water-soluble pencils and crayons are great for filling in details.

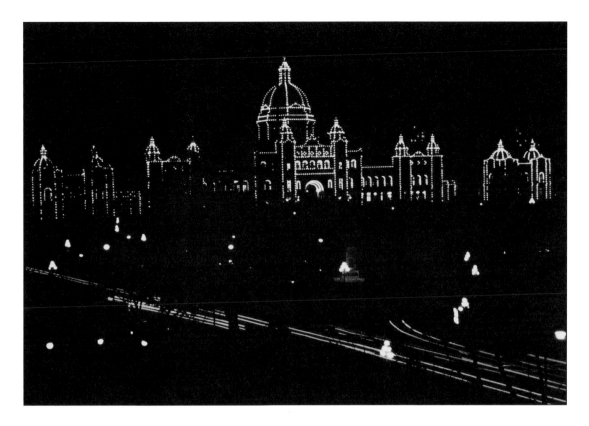

Above: The Legislative Buildings in Victoria, British Columbia cut a spectacular nighttime skyline. This three-second time exposure was printed on resin-coated paper, pearl finish.

Below: Pareaus are fabulously colorful garments sold on the streets of Waikiki. Though a color photo could have been shot, the artist liked the handcoloring challenge this image presented. (See next page for handcolored images.)

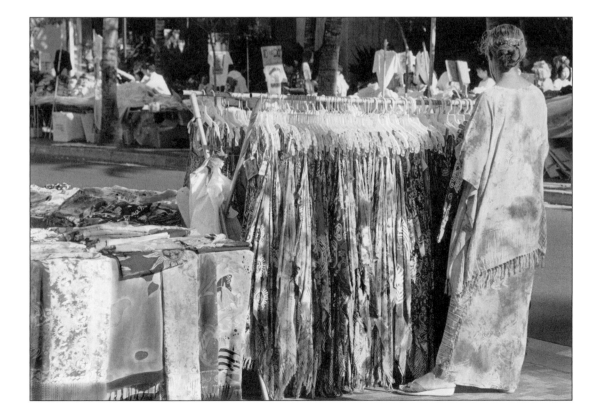

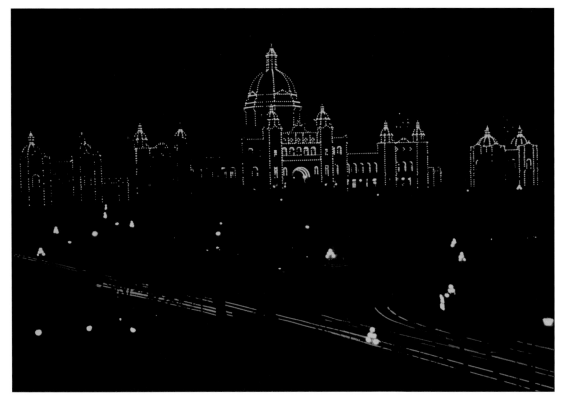

Above: For maximum color intensity, the artist applied Winsor & Newton Brilliant Watercolours direct from the jar using a 5/0 sable brush. Process Yellow was chosen for the lights and Process Cyan for the trails created by street traffic.

Below: To isolate the vendor and the rack of garments from the background clutter, the artist colored selectively using a range of undiluted Winsor & Newton Brilliant Watercolours straight from the bottle. The colors were applied randomly with a Q-tip and a 5/0 brush striving for contrast and variety. The liquid colors were deliberately allowed to mix and flow together in bright washes.

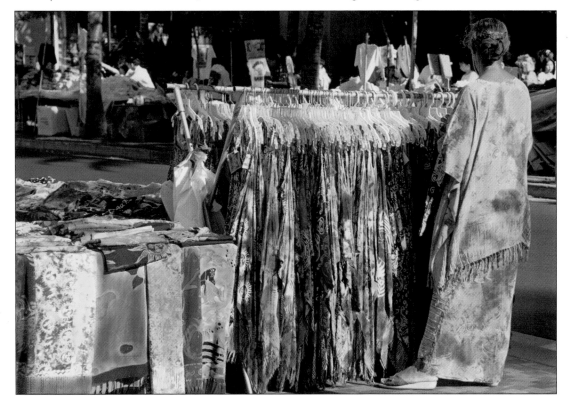

Print Considerations

Watercolors may be applied to resin-coated or fiber-based black & white prints. Watercolors adhere best to a matte finish, except for brilliant watercolors which stick to any finish.

Preparing the Print

The first step in handcoloring with watercolors is to dampen the print's surface with a solution of water and wetting agent. The wetting agent decreases the surface tension of the watercolor allowing the paint to spread smoothly and evenly.

The traditional wetting agent for watercolors is oxgall liquid, made from the gall bladders of cattle. If that turns your stomach, substitute Kodak's Photo Flo, which works nearly as well. Refer to the product packaging to determine the mixing ratio. It's usually around 100 to 1.

Use a sponge or cotton ball to apply the solution. It's much more difficult to apply watercolors when a print's surface has not been dampened. Try coloring on both wet and dry prints to see the difference for yourself.

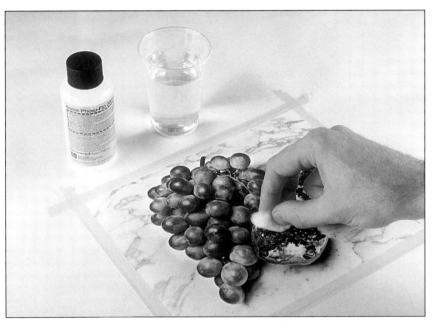

It's a good idea to apply wetting agent solution before handcoloring with watercolors.

Preparing Watercolors

Tube watercolors must be mixed with water before use or they will be too thick. Squirt a small amount of paint onto a palette or saucer, then add a few drops of water to liquify the paint and make it good and runny. The more water you add, the weaker the color will be. Stir with a brush or toothpick.

Liquid brilliant watercolors may be used straight from the bottle or diluted with water. Undiluted brilliant watercolors are highly concentrated and their

49

colors are very intense. No advance preparation is needed to use cake watercolor paints or crayons or pencils (other than sharpening the tip).

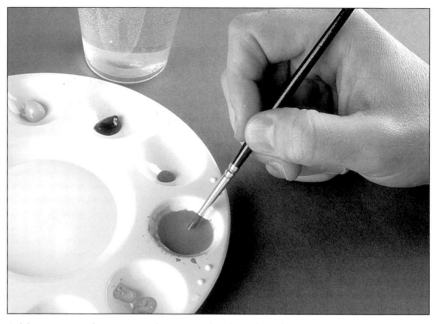

Add water to tube watercolors to make them liquid.

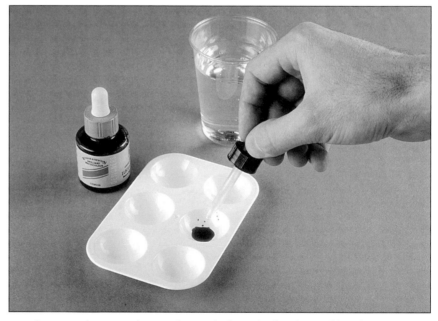

Liquid watercolors may be used straight from the bottle or diluted with water to soften the hues.

Applying Watercolors

Brushes are the best tool for applying watercolor paints. It's a good idea to have several brushes on hand: a fine-tipped brush (size 3/0 or smaller) for detail work and a few larger brushes for general use (size 2, 4 or maybe 6).

• Apply watercolors using brushes, cotton balls, Q-tips or cotton-tipped skewers.

Watercolors can also be applied with cotton balls, Q-tips or cotton-tipped skewers. In addition to brushes, cotton and color, you'll need a jar or two of water for moistening and diluting the watercolors, cleaning brushes and removing unwanted color.

Watercolors have earned a reputation among painters for being difficult to apply because they tend to run. That's no problem for handcoloring, though. Any watercolors that get where they aren't wanted are easily removed. Apply watercolor paint in thin, light washes. If you apply too much color, remove the excess with a cotton ball. Watercolors run together so don't worry about overlapping colors — that happens automatically. For large areas such as skies, use a wide brush or a cotton ball.

Brilliant watercolors are also best applied by brush, though you could use a technical pen or even an airbrush. You need to be a little more cautious where you apply brilliants. Unlike most water-based media, they're difficult to blend and remove. Sometimes it's helpful to mask portions of your print with masking fluid.

Apply crayons and pencils directly to the photograph — it's as simple as that. To smooth the application, blend with a damp Q-tip.

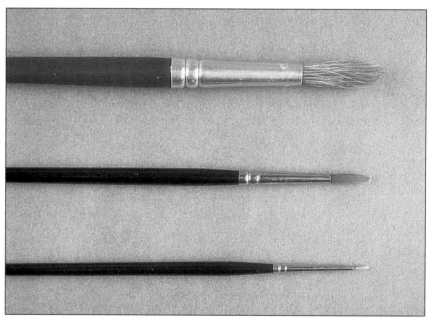

You'll need a range of natural or synthetic brushes to apply watercolors.

"Let each layer dry before applying the next one."

Layering
Watercolors are soft and subtle. To build color intensity on your photo, apply several layers of color. Let each layer dry before applying the next one.

Mixing Colors
To create new colors, mix tube watercolors on your palette. Watercolor pans usually have an empty slot meant for mixing paint. Traditionally, watercolor artists have not used the color white. Instead, they leave portions of the white paper unpainted. Because photographs aren't all white, this tradition doesn't apply to handcolorists. Go ahead and use white watercolor paint without shame.

Applying Watercolor

1 To load your brush with paint from a watercolor cake, dip the brush in water then swirl it on the cake.

2 Go easy on the color. If necessary, smooth the application using a cotton ball or Q-tip.

3 Soften the binder on a water-soluble pencil by dipping it in water.

4 Clean your watercolor brush in a jar of ordinary tap water. About once a month, remove accumulated color with warm water and mild soap.

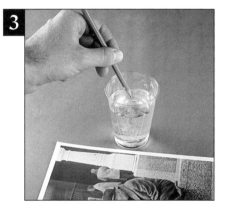

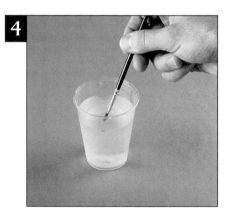

5 Wipe the brush with a paper towel.

6 Shape the bristles then place the brush in a jar to dry, bristles-up.

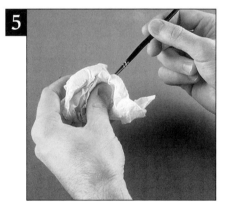

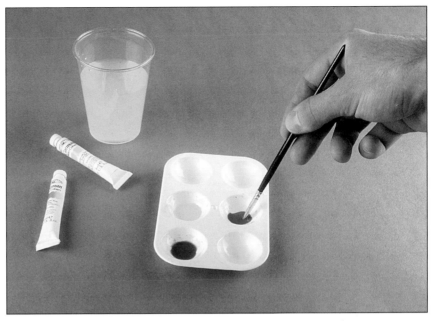

To create colors you don't have, mix watercolor paints in a palette.

"Watercolor paint is ridiculously easy to remove."

Removing Color

Watercolor paint is ridiculously easy to remove. Simply rub away unwanted color using a cotton ball or Q-tip and plenty of water. If the entire photograph's a write-off, wash it under running water, then start anew. Brilliant watercolors are different story: they're extremely difficult to remove and usually leave permanent stains.

Ordinary watercolors are easily removed with a wet cotton ball.

If you're not satisfied with the way your handcolored photograph is shaping up, wash the print under running water then start fresh.

Drying Time

• **Watercolors remain soluble in water even after they're dry.**

Once your handcoloring artistry is complete, allow the photograph to air dry for a day or so. It's normal for watercolors to lose some color intensity as they dry. Even after they're dry, watercolors remain soluble in water.

Colored Pencils

Introduction

A favorite of contemporary handcolorists, colored pencils are inexpensive, extremely easy to use and offer bright, eye-catching colors and a distinctive visual texture. Images colored with pencils often look more like drawings than photographs. Pencils are especially good for coloring intricate, detailed images.

They may all look the same, but colored pencils vary considerably from manufacturer to manufacturer, particularly when it comes to color strength, quality of construction, permanence of pigments and hardness or softness of leads. One brand of colored pencils highly recommended for handcoloring black & white photographs is Prismacolor pencils by Berol.

"...easy to use and offer bright, eye-catching colors..."

Prismacolor pencils' soft leads and strong colors make them a superb choice for the handcolorist seeking to create modern-look handcolored images.

Available in more than a hundred different colors, Prismacolor pencils feature soft leads that won't scratch your print's emulsion. Relative softness

ARTIST-GRADE

The highest grade of paints and coloring materials available. Artist-grade materials use top quality pigments for intense, light-fast color.

"Pencil colors look their brightest on fiber-based prints."

varies from color to color. Flesh 1939, for instance, is especially soft and waxy while Raw Umber 1941 is one of the harder Prismacolor pencils.

Like most handcoloring media, Prismacolor pencils are transparent, so they won't hide the image you're coloring. Derwent, Faber-Castell, Caran d'Ache and others also manufacture artist-grade colored pencils, though they offer fewer colors to choose from and their leads may not be as soft as Prismacolors'.

You can buy colored pencils at any art supply store, individually or in sets. When buying pencils one at a time, check that the leads are centered in the casings. Off-center leads are more likely to break when sharpened.

Pencil colors look their brightest on fiber-based prints. Like high quality drawing paper, fiber-based photographic paper grabs the pigment, leaving a pleasing line of color with each stroke.

Colors don't render as dramatically on resin-coated paper as they do on fiber-based prints. Whether coloring fiber-based or resin-coated prints, it's imperative that the finish is matte. Pencil colors don't stick to semi-gloss or glossy finishes.

Preparing the Print

Applied to a dry photograph, colored pencils leave visible strokes which, for many handcolorists, is part of their appeal.

If a smoother finish is what you're after, apply a light coat of mineral spirits to the portion of the photograph you plan to color *before* you start coloring. The mineral spirits will liquify the binder so the pigment washes over the print.

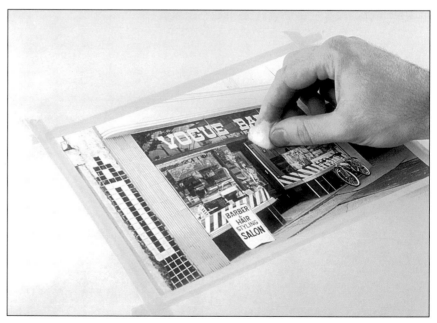

When coloring with pencils, first coat the photograph with solvent to smooth the application, or color directly on the dry photograph in obvious strokes.

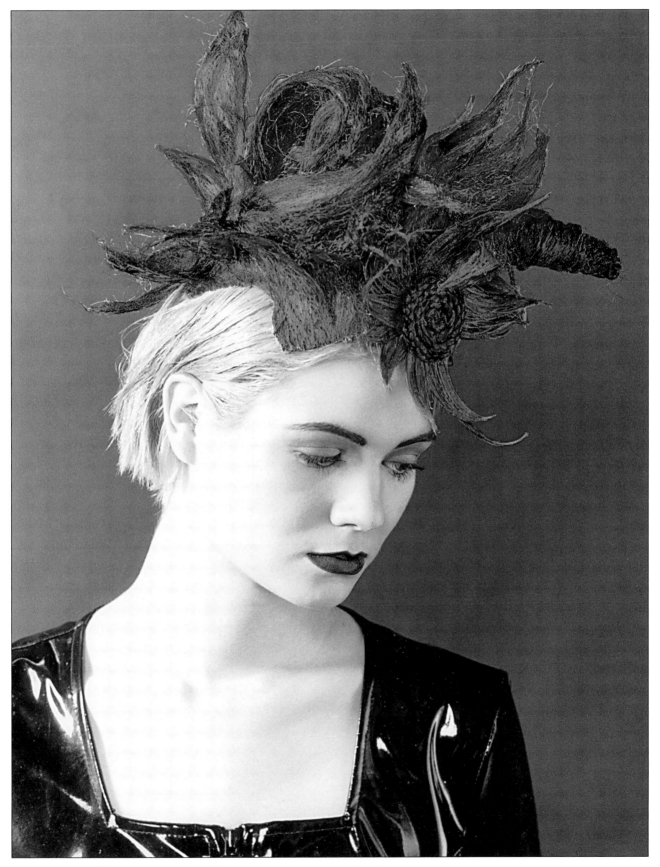

Fashion images like this one are ideal for handcoloring with colored pencils.

Sculpting Pencil Tips

• **A sharpener, an X-acto knife and a sheet of fine sandpaper are needed to sculpt pencil tips.**

To sculpt your pencil tips into practical coloring tools, you'll need a sharpener, an X-acto knife and a sheet of fine sandpaper. Keep the sharpener clean and change its blades frequently. Dull blades break leads. Because most sharpeners use fixed-position blades to sharpen pencils to one preset conical shape, you may wish to use the X-acto knife to trim or modify the exposed lead for the particular coloring application at hand.

Once sharpened and shaped to your satisfaction, you can smooth, peak, flatten or round the tip of the pencil by rubbing it on the sandpaper. Before coloring, wipe the tip on a paper towel or pencil cleaning pad to remove dust or grit.

An electric pencil sharpener can be a real timesaver, especially if you've just purchased a brand new pencil set with dozens of colors to sharpen. Good electric sharpeners have blades that retract after the tip is sharp so they don't eat up the pencil. Electric pencil sharpeners also spare your hands needless blisters!

Photocopies are great for brainstorming coloring ideas.

Applying the Color

Photographic paper's emulsion is quite delicate and easily damaged by heavy pencil pressure, so color with a light touch. When coloring details, hold the pencil like you would any writing instrument.

To color backgrounds or any large area, switch to an overhand grip coloring with the side of the lead. As you might expect, a fine point works best for detailed work while a round point is best for coloring larger areas. Prismacolor pencil leads are very soft and don't stay sharp for long.

Any time you color a black & white photograph with pencils you're likely to see pencil lines, even if you smooth the application with mineral spirits. This makes the direction in which you color important.

One practical strategy is to apply the color following the grain or texture of the object you are coloring. For instance, when coloring a wooden bench, color back and forth in the direction of the wood grain so the pencil marks enhance the bench's texture.

If you elect not to prepare your photo's surface with solvent, here's a trick you can use to minimize pencil strokes in small, select areas: dip the pencil tip in mineral spirits before coloring with it.

To some degree, you can vary the intensity of the colors you apply by increasing or decreasing the pressure you exert on the pencil. Light pressure will produce a sparse covering of pigment. Heavy pressure builds up the density of coverage. You can alternate light and heavy pressure within particular areas to achieve a mottled effect or a color gradation.

Smoothing

To smooth away pencil lines on a dry photograph, lightly rub the photograph with a Q-tip or cotton ball dipped in mineral spirits. If you've already prepared the print's surface with mineral spirits, a dry Q-tip or cotton ball should do the trick. Another way to smooth away pencil strokes is using a colorless marker— a marker that has no color of its own but contains a solvent that liquifies the lead's binder.

• You can smooth away pencil strokes by using a colorless marker.

Most colorless markers use powerful, highly toxic solvents, so you may find the smell unpleasant. After blending with a colorless marker, run out any color picked up by the marker on scrap paper so it's ready for next time

A colorless marker is a convenient, but highly toxic way to eliminate pencil strokes.

Mixing Colors

"...add complexity and richness to an area..."

Because pencil colors are transparent, layering one color over another optically mixes the colors. You can use layering to mix a color not directly available as a pencil, to add complexity and richness to an area or to reduce the brilliance of an applied color.

Applying Colored Pencils

1 Colored pencil leads are soft and break easily, so be gentle sharpening them. After the initial sharpening, a few light twists should do it.

2 If necessary, use an X-acto knife to modify the contour of the sharpened lead.

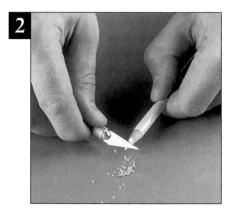

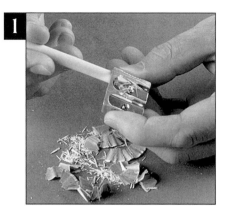

3 Refine the pencil tip on sandpaper making it rounder, flatter, smoother or sharper as the application demands.

4 For coloring small areas and details, hold the pencil like you would when writing.

5 To color backgrounds and large areas, hold the pencil in an overhand grip coloring with the side of the lead.

6 When your favorite color gets worn down to a stump, attach a pencil lengthener to make it easier to hold.

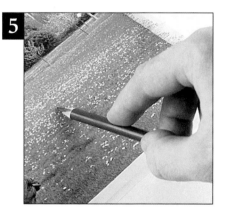

When layering colored pencils, don't get too carried away — too many layers creates a muddy build-up of pigment and wax that obscures the image.

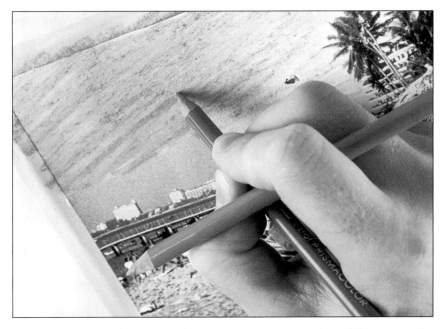

One way to mix colors is to color an area using two or three different pencils.

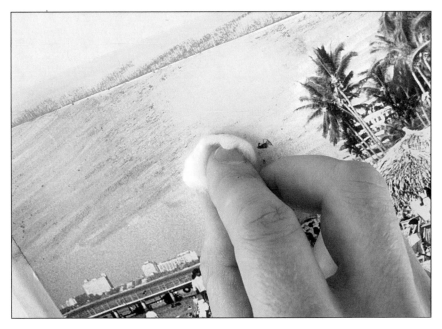

Then mix them all together using a solvent-soaked Q-tip or cotton ball.

Most pencil colors are bright so there may be occasions when you wish to deaden a color — perhaps when coloring a night scene, a rainy day setting or a background.

To dull the intensity of an applied color, layer a neutral gray, black or a darker hue of the applied color over top.

IMPRIMATURA

The technique of coloring the entire photo one solid base color, then layering all other colors on top. Results in complex color mixing which serves to unify the color scheme.

"...create the effect of a painterly mosaic or a comic book."

An extreme form of layering is what artists call imprimatura. Instead of layering colors on only a portion of the image, you color the entire photograph with one pencil then layer all other colors on top.

The benefit of imprimatura is that it's quick to do and the base color serves to unify the color scheme. Although you could achieve a similar effect by toning or dyeing the photograph, the smooth texture of the toned areas would fight against the pencil textures.

Another way to mix colors requires mineral spirits. Simply color the area using two or three different pencils, then mix them all together using a solvent-soaked Q-tip or cotton ball.

You'll find this technique effective for adding visual complexity to your work. For instance, to recreate the varied colors of an autumn tree, apply several related browns and yellows.

Edging

By accenting the edges of objects you can create the effect of a painterly mosaic or a comic book. You can use a straight edge or even your fingernail to guide the pencil along its path.

You can also use French curves for edging. French curves are templates useful for coloring around curved areas. You should be able to find these templates at an art supply store.

Another more simplistic way to accent edges is to use a scrap sheet of paper as a straight edge. (See photos on opposite page.) This is an effective yet easy and inexpensive edging technique.

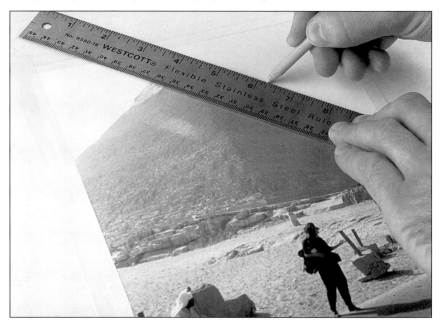

Every now and then a straight edge comes in handy.

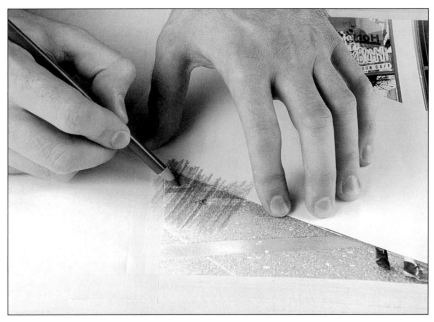

Looking for a quick and easy way to mask areas of your photo?

Try a sheet of scrap paper.

Removing Color

To remove unwanted pencil color, rub gently with a Q-tip or cotton ball soaked in mineral spirits. On dry color you have another option: using an eraser. Soft gum or putty erasers work well for most applications, though you may want to keep a harder eraser on hand for clearing tiny details.

Above: Handcoloring gives you a way to present a fresh interpretation of sites around your city or town that local photographers have shot many times before. This rocketship is actually an outdoor statue shot from a low angle to avoid buildings in the background and to make the ship seem Jupiter-bound.

Right: Eye-catching pencil hues are appropriate for fashion photographs where the colored image must be anything but ordinary.

Above: The rocket was colored using Prismacolor Cloud Blue 1023 and Metallic Silver 949. The colors were streaked with a solvent-dipped Q-tip to enhance the hand-drawn effect. The flames were colored with Orange 918 and Crimson Red 924. The background was colored using Black 935 with streaks of Indigo Blue 901 following the direction of flight. The edges where the background meets the ship were kept crisp using French curves. Finally, Orange and Crimson Red highlights were added to the main body and a few silver stars were glued on.

Left: Using Prismacolor pencils, Canary Yellow was applied to the glitter balls. Notice how the studio lighting has taken care of the highlights and shadows. Next, Canary Yellow 916, Carmine Red 926, Crimson Red 924 and Orange 918 were applied to the hair in loose swirls, roughly following the direction of the hair's curls. The mask was colored Metallic Gold 950 and Deco Yellow 1011, the model's eyes Limepeel 1005 and her lips and dress straps Crimson Red.

One way to remove unwanted color is using a cotton ball or Q-tip dipped in mineral spirits.

• **After washing the eraser, make sure it's dry before using.**

When using an eraser, try to remove the unwanted pigment without rubbing down the photo's emulsion. Make sure the eraser is clean so you don't smear color all over the place. Most erasers can be washed in warm soapy water. Dry the eraser thoroughly before use.

Dry pencil color may be removed with an eraser. For greater control, use an eraser shield.

WAX BLOOM

A hazy coating that can form on a photo colored with pencils. Caused by wax working its way to the surface of the photo.

Drying Time

Colored pencils applied to a dry image require no drying time whatsoever. If you've applied a solvent, give the image a few minutes for the solvent to evaporate before matting or framing.

A week or two after completing a heavily layered application you may notice that a slight haze has formed on your photograph's surface. This so-called "wax bloom" is the natural movement of wax from the binder that holds the pigment and nothing to worry about. To remove wax bloom, gently rub the photograph's surface with a soft cloth, taking care not to smudge the colors. You can inhibit wax bloom by spraying the image with a spray finish or fixative immediately after completion.

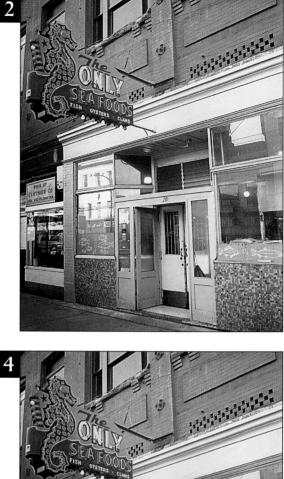

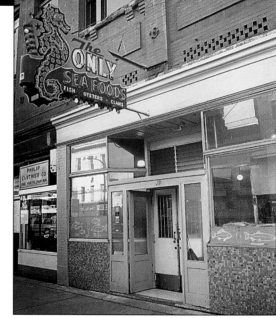

 This image provides plenty of intricate detail which makes it a good candidate for handcoloring with Prismacolor pencils.

2 Working with the sea theme implied by the signage, the artist decided to use a color scheme centered on blues and greens. A range of harmonious colors were applied to the image's main point of interest, the neon seahorse. Prismacolor neon pencils came in handy for coloring the main neon tube and the seahorse's eye. Notice the neon green edging around the seahorse's spots added for emphasis.

3 After applying mineral spirits to the building, Deco Blue 1015 and Yellow Chartreuse 1004 were applied and smoothed. The door was left a little rough (elements that are "too perfect" tend to look either surreal or boring). Notice how green is layered over blue on the facade to create blue-green.

4 Next, subtle touches of color were added to the objects and reflections in the window using pale colors and a light touch. Look closely and you'll notice a soft reflection of the seahorse. Sharp blue and green pencils were used to color the tiles.

5

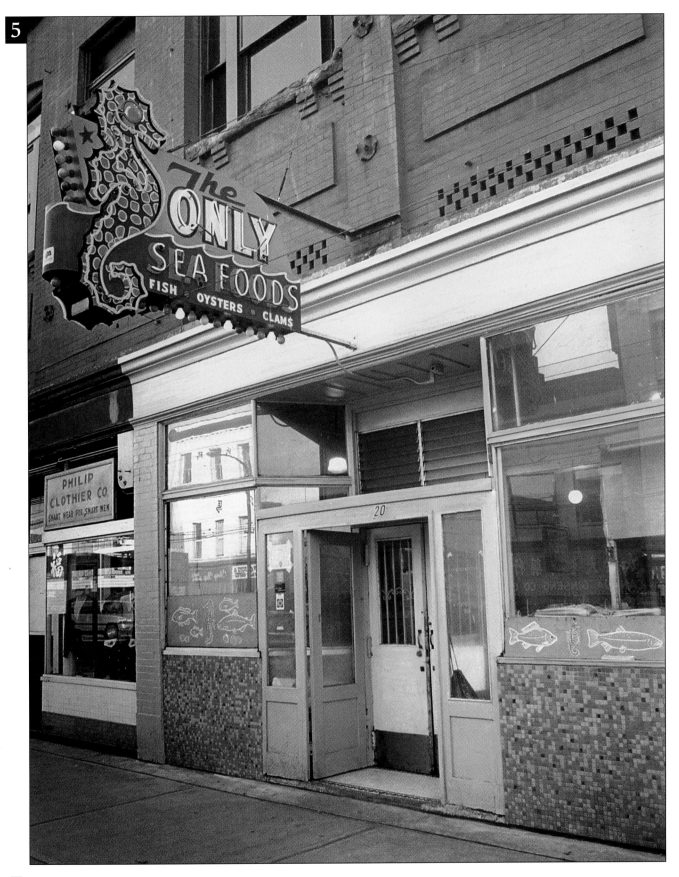

5 To finish this handcolored image, the sidewalk and building next door were colored. Total coloring time: 12 hours.

<div style="text-align:center">

CHAPTER SIX

Other Media

</div>

Introduction

Oils, watercolors and colored pencils are exceptional media for handcoloring black & white photographs, but they're not your only options. You may also wish to try retouching dyes, markers, acrylics, inks, gouache or just about anything else that stains or marks a print.

Retouching Dyes

Meant primarily for spotting color prints, retouching dyes, such as Marshall's Photo-Retouch Colors and the Berg Color Retouching Kit, double as a handcoloring medium.

Water-soluble and completely transparent, retouching dyes produce hand-colored results very similar to those produced by the liquid watercolors of Winsor & Newton and Dr. Ph. Martin.

Like liquid watercolors, retouching dyes are highly concentrated, so you may want to dilute them with water to achieve the desired strength. They adhere to all kinds of photographic paper, no matter what the finish.

Retouching dyes are a water-based medium very similar to brilliant watercolors.

Markers

Bold. Intense. Modern. High-impact. These are just a few words that describe markers as a handcoloring medium.

Seldom are markers used to color every square inch of a photograph — that's too much for the eye. Instead handcolorists use them to add crisp accent lines, bold strokes of unblended color in the pop art style.

There are two basic types of markers you can use for handcoloring black & white photographs: solvent-based markers and water-based markers. Many illustrators and graphic designers who work with markers on a regular basis prefer water-based markers because they employ no noxious solvents. Markers come in an array of colors, shapes and sizes, with felt tips ranging from extra-fine to super-wide.

One brand of markers recommended for handcoloring is Staedtler's marsgraphic 3000 series. With one hundred colors to choose from, these odorless, water-based markers feature dual tips: a soft foam tip for smooth color

"Markers come in an array of colors, shapes, and sizes..."

Markers are great for creating contemporary pop art effects.

and a fine point fiber tip for thin lines. Berol also manufactures markers under the Prismacolor label.

Markers can be used on any brand, type or finish of photographic paper, but their slick, clean colors are best-suited to glossy resin-coated prints. Your print requires no preparation, simply choose your color and away you go. You'll find that smooth, steady strokes and a light touch yield the best results; don't pause at the start or finish of the stroke or the ink may "pool".

A properly functioning marker should leave a clean, even, transparent mark. Uneven marks and a loud squeak indicate the marker is getting dry and it's time for a new one. With a bit of practice you'll be able to manipulate line width by rolling the marker and varying the application angle.

Most markers render color that's extremely difficult to smooth or remove, though you may be able to soften edges using solvent or a colorless marker immediately after application.

When using solvent-based markers, work in a well ventilated area and cap each marker immediately after use. Before capping, clear away any color picked up by the tip by rubbing it on scrap paper.

Acrylics

Acrylic paints are an opaque medium characterized by bright, flat colors. Invented in the 1940's, acrylics use the same pigments as all other paints but bind them in an emulsion of minute plastic particles in water.

Because they're water-based, acrylics can be thinned and cleaned with tap water. Acrylics are very quick drying and, unlike watercolor paints and gouache, dry to a tough, waterproof finish.

• **Acrylics dry very quickly and have a waterproof finish.**

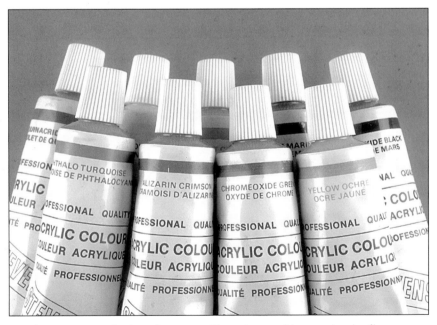

Acrylic paints are thick and opaque. They dry quickly to a bright, flat, waterproof finish.

Above: This image was handcolored using Berg retouching dyes. Retouching dyes are water-soluble, completely transparent and highly concentrated. You may want to dilute them with water to achieve the desired strength. These dyes adhere to all kinds of photographic paper, no matter what the finish.

Right: Staedtler marsgraphic 3000 water-based markers were used to handcolor this photograph. (Photographer: Jessie Morton Laird.)

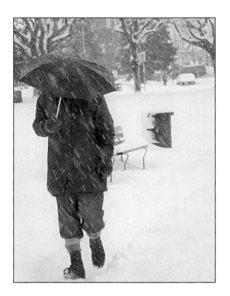

The covering power of Stevenson's Titanium White acrylic paint was used to hide background clutter and purify the fallen snow. Compare the original (left) to the hand-colored result (below).

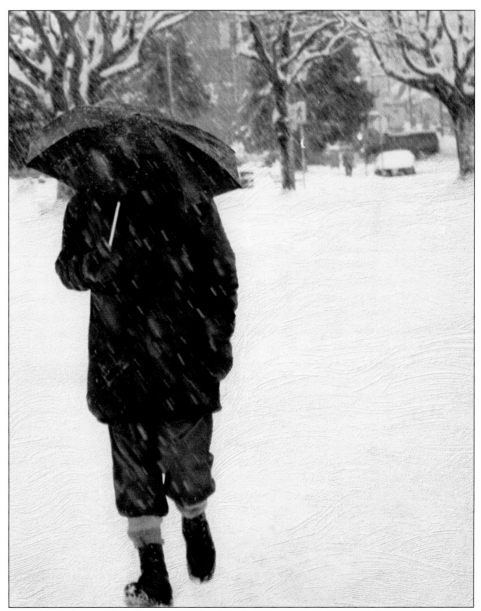

Inks may be applied by brush or from the tip of a pen.

Gouache is thicker and more opaque than watercolor paint.

Inks

Water-based inks can be used in much the same way that retouching dyes and liquid watercolors are used — and to nearly the same effect. One limitation presented by inks, however, is that few earth tones are available.

An exceptional novelty product that you may wish to experiment with is metallic ink pens such as Sakura's Pen-touch and Pilot's Super Color pens. Great for adding highlights, these pens are easy to use, quick to dry and adhere to most photographic paper. When using pens, be careful not to scratch the print's surface.

Gouache

Gouache (rhymes with squash) is similar to watercolor paint, but thicker and more opaque due to the presence of precipitated chalk in the binder. Sometimes called designer's paint or poster paint, gouache is suitable for heavy-handed coloring applications where you need strong, thick color to obscure portions of your photograph. Gouache dries quickly to a dusty, matte finish.

Anything Else that Adds Color

Other coloring media you may wish to experiment with include spray paints (usually used with masking), enamel hobby paints, powdered pigments mixed with homemade binding agents, or anything else you can come up with. Manufacturers continue to develop "new and improved" coloring media, so keep your eyes open at the art supply store for new products.

When you do come across a new medium, use these criteria to help evaluate its handcoloring potential:

- How well does it adhere to photographic paper?
- Is it transparent, opaque or somewhere in between?
- How easy is it to use?
- How safe is it to use?
- Is the color permanent or will it fade?
- How much does it cost?

CHAPTER SEVEN

Mixing the Media

Introduction

With so many different coloring media at your disposal, each with its own unique characteristics and special appeal, often the most practical way to handcolor is using several different media on the same print. You might, for instance, want to use photo oils to color faces and hair, then colored pencils for the eyes and lips. Or you might like to paint skies with watercolors and trees with oils. Or you might like to dye your print before handcoloring. The possibilities are endless!

When using more than one medium, it's important to realize that not all media are compatible. Also consider that, depending on the combination of media you select, you may have to apply the color in more than one handcoloring session.

Basic Guidelines

"In the world of art there are no strict rules..."

In the world of art there are no strict rules, but here are a few basic guidelines to get you started with mixed media.

- Always tone or dye *before* handcoloring. If you tone or dye afterward you'll damage the hand-applied color and contaminate your solution.

- Not all brands, types and finishes of photographic paper work with all media. Retouching dyes, for instance, stick to glossy paper; colored pencils don't.

- All oil-based media may be used together on the same photo.

- All water-based media may be used together on the same photo.

- Oil paints and pastels may be applied over pencil colors, but not the other way around. Pencils may scratch away the underlying color.

- Oil-based color may be applied on top of water-based color if the watercolor is absolutely dry. Water-based color, on the other hand, will not adhere to oil-based color.

Above: Here the sky was colored with oil paints, the bridge with oil pastels, the buildings with colored pencils, and the boat with acrylic paints.

Right: In this photo, the larger fruits, like watermelons, were colored with Caran d'Ache oil pastels. The smaller fruits, like plums, were colored with Prismacolor pencils.

Summary of Oil-Based and Water-Based Media

Oil-Based Media	Water-Based Media	Other Media
Oil paints	Watercolor paints (tubes and cakes)	Colored pencils
Photo oils	Brilliant watercolors (liquids)	Markers
Oil pastels	Retouching dyes	Crayons
Wax-oil crayons	Acrylics	
Oil bars and sticks	Inks	
	Gouache	

Three different media were used on this image: oil paints for smooth, rich color in the sky and background, watercolors for delicate touches in the pond, and colored pencils for sharp lines on the pagoda.

• **Water-based and oil-based media can be used to handcolor the same print.**

Mixing Oils and Watercolors

It's possible to use water-based and oil-based media on the same black & white print, but keep these points in mind: Watercolors penetrate the photo's surface, but can't penetrate oil paints, pastels or colored pencils that cover the photo's surface. Oil-based colors sit on the photo's surface and can cover watercolors, but only if the watercolors are dry. When using water-based and oil-based media on the same print, be careful not to wipe away the watercolors with solvent.

Five Mixed Media Techniques

1. Sepia toning before handcoloring.

2. Handcoloring with oils then using solvent-type colored pencils for detailing. Or handcoloring with watercolors then using water-soluble pencils for detailing.

3. Adding opaque touches to a print colored with watercolors using gouache or acrylic paint.

4. Using wax-oil crayons to add texture to oil-painted prints, or using water-based crayons to add texture to watercolor prints.

5. Adding final touches to any image with a metallic ink pen.

These are by no means the only media combinations. Experiment! Try your own combinations. There are no mistakes, only explorations. Plus, experimentation is a good way to break out of an artistic rut.

CHAPTER EIGHT

Handcoloring Tips

Introduction

In this chapter, you'll find a few helpful handcoloring tips and suggestions.

Where Do I Start Coloring?

"...a few practical coloring strategies to help you get started."

Laying down the first strokes of color can be a little intimidating. After all, no one wants to ruin a perfectly good black & white print! There are as many ways to handcolor as there are photographs, but here are a few practical coloring strategies to help you get started.

Subject then Background

One effective handcoloring strategy is to color the main subject (person or object) first, then fill in the background. This allows you to choose the subject's colors with complete freedom then later pick background colors to complement or contrast the subject. This way the colors of the subject dictate the colors of the background, and not the other way around.

Least Detailed Areas First

Some handcolorists prefer to color the large areas first then move to regions of increasing detail, constantly refining the image as they go.

Left to Right

For the right-handed colorist, the advantage of coloring from left to right is that you avoid dragging your hand through the colors you've just applied.

Top to Bottom

Working from top to bottom is another way to avoid smearing freshly applied colors.

Freestyle!

For many artists — painters, musicians and handcolorists, too — the best way to work is freestyle, forgoing any rigid system or method. Improvising. Making it up as you go along. Just listen to the colors, they'll tell you where they want to go!

In this photo, selective coloring is used to focus attention on the building in the foreground.

Left: "Billboard" depicts an advertisement on a crumbling wall in downtown Cairo, Egypt. The photograph was colored with Prismacolor pencils.

Below: This image was also colored with Prismacolor pencils.

How Much Color Should I Apply?

How much of the image should I color? All of it? Would it help to leave the background untouched? Should I color the entire face or just the eyes and lips?

One sure way to answer these questions, if you have plenty of time on your hands, is to try all the different combinations you can come up with, put them side by side, then pick the one you like best.

One thing to make clear in your mind when handcoloring is the part of the image that you want to draw attention to. Say you're coloring a photograph for a lipstick advertisement and, logically, you decide to accent the model's lips. In this case, coloring the eyes, hair and face may only serve to distract attention from the lips. Also consider that, generally speaking, selective coloring gives your handcolored photograph a contemporary look, while complete coverage tends to look traditional or nostalgic.

Special Darkroom Techniques

Developing your own photographs in the darkroom gives you the opportunity to lighten, darken or even block out areas of an image based on ideas or notions you have for handcoloring that print. Probably the most valuable darkroom technique for the handcolorist is dodging — restricting the light to an area of the developing print to keep it lighter. The lighter the image, the brighter transparent colors will appear when you handcolor. Burning in is just the opposite of dodging — giving an area of the photograph additional exposure time to darken it. Even after your photograph is developed it's still not too late to lighten it by bleaching all or part of the image.

Combining Handcoloring with Other Photographic Techniques

Handcoloring may be used on its own or in combination with other photographic techniques such as solarization, reticulation or montage. Infrared photography looks great handcolored, and so do high contrast prints. Again, try anything you like. Don't be afraid to push the boundaries.

Airbrushing

An airbrush is a mechanical device that uses compressed air to fire paint, ink, dye or other liquid color at the print. It can be set to deliver anything from a narrow stream of color up to wide spray. Learning to use and handle an airbrush takes considerable practice — and the required equipment is expensive — but in the end the airbrush delivers slick, highly professional results.

DODGING

Restricting light to an area of the print during exposure to keep it lighter than the rest of the print.

"Don't be afraid to push the boundaries."

Color Theory

Introduction

Choosing the colors *you* want to see is part of the joy of handcoloring. This chapter offers a few tips and guidelines to help you get the most from the colors you use.

Realistic Versus Non-Realistic Color

In terms of color, all handcolored black & white photographs can be grouped into two categories: photographs that are realistically colored and those that are not.

Think of realistic color as an accurate, natural representation of the subject, the kind of handcoloring often used for portraits, landscapes and traditional handcolored art. The goal of realistic color is to bring the image to life, usually in a complimentary fashion.

To achieve realistic color, you may wish to refer to Polaroids or color snapshots of the subject and setting, or you can simply work from memory. When coloring realistically, the colors you choose are the ones that most closely match the actual colors. For instance, you will color a person's skin in a natural skin tone, not bright green or navy blue.

Non-realistic color, on the other hand, yields an artistic, fanciful representation of the photographic image. With non-realistic color, you're free to alter or exaggerate an image's colors in any way you wish, whether to communicate a certain feeling or emotion or simply to make the image look the way you want it to look.

Certain handcoloring media are better suited to achieving realistic color, while others are better for non-realistic color. Oil-based media, with their rich, smooth colors, are good for rendering realistic flesh tones and greenery. Colored pencils and markers are better for non-realistic interpretations because their colors are unnaturally bright and they leave a definite visual texture.

"...you're free to alter or exaggerate an image's colors..."

Above: Realistic handcoloring attempts to render the image in its natural colors.
Below: Non-realistic handcoloring allows for fanciful interpretations of the subject matter.

Red, yellow and blue are the primary colors.

Mixing two primary colors yields a secondary color. For example, blue and yellow make green.

Definitions

When talking color, a few technical terms frequently pop up.

Hue: Just another way of saying color.

Tint: A mixture of a color with white. Pink is a tint of red.

Shade: A mixture of a color with black. Crimson is a shade of red.

Tone: A mixture of a color with gray.

Intensity: The brightness or dullness of a color.

Value: The lightness or darkness of a color.

Mixing Pigments

When to Mix

The only time you need to mix colors for handcoloring is when no ready-to-use color in your palette is exactly right for the application at hand. Perhaps you wish to color a model's dress orange, but find one orange in your palette is too bright, the next too dark. Or maybe you have only a small set of basic colors, so you need to mix these colors to expand your color range. Buying large multi-piece sets of coloring media reduces the need for mixing, but doesn't eliminate it. No matter how many colors in your palette, eventually you'll need to mix.

As you gain experience mixing colors you may find yourself less and less satisfied with ready-to-use colors. Master painters seldom use colors straight from the tube. They find that mixing their own color combinations gives their work greater visual complexity and a unique, personal style.

How to Mix

The basic rules of color mixing apply to all handcoloring media except chemical toners. The only difference from medium to medium is when and how mixing is done.

For instance, paints are usually mixed on a palette before being applied to the photograph. Pastels and pencil colors are mixed directly on the photograph. Liquid dyes and inks are usually diluted with water then mixed in an ink well or small jar.

The Three-Primary System

To help understand the mixing of pigments, artists rely on the three-primary system of color mixing. According to the three-primary system, all of nature's infinite colors can be created by combining the three primary colors — red, yellow and blue — plus varying degrees of black and white. The primary colors are sometimes called pure colors because they can't be created from the other primaries; that is, red contains no yellow or blue, yellow no blue or red, and blue no red or yellow.

Mixing all combinations of two primary colors together in equal proportion produces the three secondary colors: green, violet and orange. Green is a mixture of yellow and blue, violet a mixture of blue and red, orange a mixture of yellow and red.

• **Mixing your own colors gives your images a unique, personal style.**

Going one step further and mixing one primary color and one secondary color, again in equal proportions, yields the six tertiary colors: red-orange, red-violet, yellow-orange, yellow-green, blue-green and blue-violet.

Using a Color Wheel

The color wheel is a handy, inexpensive device for predicting the outcome when colors are mixed. Around the wheel's perimeter you'll notice the three primary colors, the three secondaries and the six tertiaries arranged in a specific order.

By rotating the center wheel to a given position, you can see the result of mixing any of the primaries, secondaries or tertiaries with red, yellow, blue, white or black.

It's important to realize that the color wheel offers an idealized version of color mixing. In practice, color mixing isn't quite so predictable or precise. Mixed colors are usually muddier than the color wheel might lead you to expect.

If you're new to color mixing, you may wish to try making your own color wheel using any one of the handcoloring media. Don't get discouraged if your results are disappointing at first — color mixing takes practice.

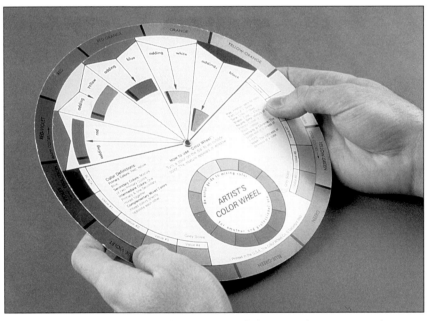

Use a color wheel to predict the outcome when two colors are mixed.

Lightening a Hue

Light colors can be used to create quiet visual moods or to contrast darker hues. To lighten any hue, simply add a touch of white or a lighter value of the same hue. An alternative way to lighten a hue is by applying the color in a thin coat letting white from the photograph show through. This has the effect of mixing the color with white.

Darkening a Hue

Dark colors are often used to accent the subject or objects, or to deepen shadows. To darken a color, add black or a darker value of the same hue.

COLOR WHEEL

A handy, circular chart that helps predict the result when two colors are mixed.

"Light colors can be used to create quiet visual moods..."

Lightening a hue: Add white to lighten a color.

Darkening a hue: Add black to darken a color.

Dulling a hue: Add gray to dull or deaden a color.

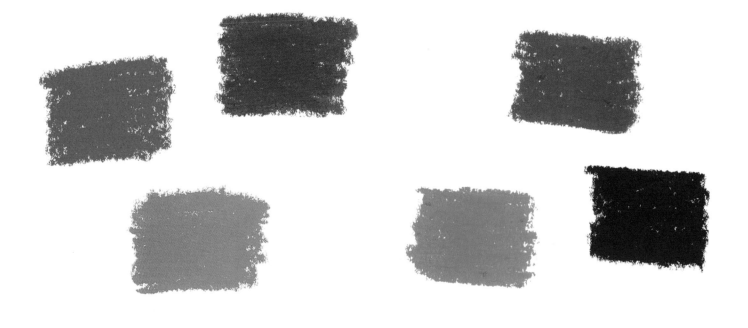

Red and orange are warm colors.

Blue and green are cool colors.

Variations of a particular color can be categorized as warm or cool. The violet on the top is cooler than the violet on the bottom.

Colors positioned directly opposite one another on the color wheel are called complementary colors because they contrast and intensify one another.

Often you'll have a number of blacks to choose from — flat black, blue-black or brown-black, for instance.

Dulling a Hue

When it comes to color, "dull" doesn't mean boring, it means the opposite of bright. The brightest, most vivid colors in your palette are the unmixed, ready-to-use colors you bought at the art supply store. To dull or deaden a hue, mix in a touch of gray.

Harmonizing Colors

Colors, like people, have unique, individual characteristics. Green, for example, is natural, tranquil, cool and fresh. Purple is elegant, artificial, regal. Also like people, colors form relationships; some colors complement each other, others clash.

There's also a psychological aspect to color. Sometimes we associate colors with feelings or emotions, for instance, white with innocence or naivete, or blue with loneliness or sadness. These psychological associations vary between societies and cultures, as well as from person to person.

Warm Colors, Cool Colors

All colors can be categorized as either warm or cool. That means they're either biased to red (warm) or to blue (cool). Warm colors are vibrant, bold, and grab our attention. That's why stop signs are red. Red, orange, yellow and brown are warm colors. Cool colors are fresh, calm and soothing. Blue and green are cool colors. Variations of a particular color can also be described as warm or cool. For instance, a purplish red is cooler than an orange-red. It's generally observed that cool colors recede or make the colored object appear smaller, while warm colors come forward or make the object appear larger.

It's usually best to mix warm colors with warm colors and cool colors with cool colors. This leads to purer, cleaner mixed colors. Occasionally you may mix colors to "warm-up" or "cool-down" a particular color. For instance, if crimson red is just too bold and hot for your photo, mix in a hint of ultramarine to cool it down.

Complementary Colors

Colors positioned directly opposite each other on the color wheel are called complementary colors. Red and green are complementary, so are yellow and violet, and blue and orange. Placed side by side, complementary colors contrast and intensify one another. Contrast is a one of the most frequently used tools for generating visual interest in an artwork.

Similar Colors

Similar colors appear next to each other on the color wheel. Because they share related elements, they can be used together on the same photograph harmoniously.

"Colors...have unique, individual characteristics."

• **It's best to mix warm colors with warm colors and cool colors with cool colors.**

Natural Colors

In the broadest sense, any color appearing in nature is a natural color. These are the familiar colors we're used to seeing everyday, the ones that are friendliest to the eye. Because we're used to looking at them, all natural colors are harmonious. Yellow ochre and burnt sienna are just two of hundreds of natural colors.

Choosing Colors

When choosing colors and a color scheme, follow your personal taste and inclination. No matter what theories may be proffered about color, ultimately the decision rests with you. If you don't like purple and decide not to color with it, that's perfectly alright. Throw the tube out the window. By choice, you're defining your own unique palette of colors. Experiment! Most handcoloring media can be removed and reapplied so there's never any harm in trying.

"...follow your personal taste and inclination."

Handcolored photographs make great cards, gifts and mementos.

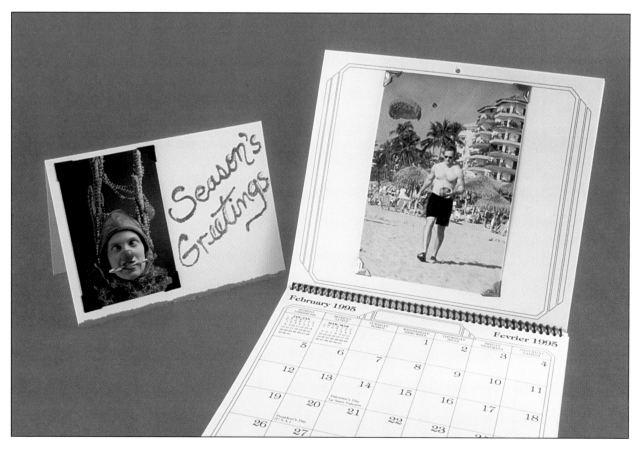

This handcolored photograph features earth tones and pastels, which create its warm-toned color scheme.

Presenting Your Artwork

Introduction

Each and every handcolored photograph you create is a one-of-a-kind work of art, unique and irreplaceable. With a little love and care, your handcolored masterpieces can resist degradation, fading and other damage to last for a hundred years or more.

Spray Finishes

Spray finishes, such as Krylon Crystal Clear, can help extend the life of your handcolored photograph by protecting its surface from the attack of moisture and air contaminants. They're especially effective at guarding watercolors from moisture damage and pencil colors from wax bloom. Available in matte and glossy formulas, some spray finishes contain ultraviolet absorbers that shield the image from the sun's most destructive rays.

If you choose to spray finish your handcolored photograph, make sure the photo is absolutely dry, then apply a thin, uniform coat. Take all necessary safety precautions because spray finishes are toxic by inhalation. Once applied, you'll probably find that your photo's colors look a touch darker than before you sprayed.

Photographs handcolored using Marshall Photo Oils may be protected by applying a light coat of Duolac, the Marshall-brand photo protectant.

Matting and Framing

The best way to protect a handcolored photograph from tears, punctures, curling, discoloration and deterioration is by mounting it in a hinge mat and framing it behind glazing. A hinge mat consists of a mat and a backboard joined by tape. The photograph is then fastened to the backboard with tape or photo corners. The purpose of the hinge mat is to keep the photograph from touching the glazing or frame. Acid-free museum board, made from high-grade cotton fiber, is the best material for mats and backboards; acids in ordinary mats eventually damage the print.

Other matting techniques such as cold mounting, heat mounting and wet mounting are not recommended for handcolored photographs. They require pressing, rubbing, heating or wetting the print, which can smear or

SPRAY FIXATIVE

An aerosol spray applied to the surface of a handcolored photo to protect it from moisture and contaminants.

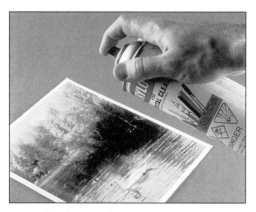

Spray finishes can be used to protect your photograph and give it a glossy sheen.

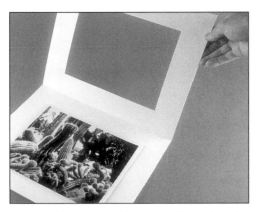

A typical hinge mat. The mat is hinged to the backboard with tape and the photo secured to the backboard using photo corners.

- **Mounting and framing your hand-colored photograph is the best way to protect it.**

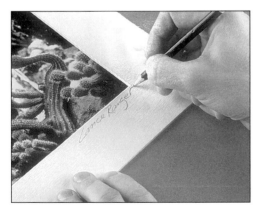

Using a hard pencil, artists sign and some-times date the framed image on the bottom right corner of the mat. It's unusual, but not unheard of, for a handcolorist to sign direct-ly on the photo using a colored pencil or brush and paint.

otherwise damage the coloring. You could, however, use any of these methods to mat a black & white photograph and *then* handcolor it.

After securing the handcolored photograph in a hinge mat, you can mount the photograph, mat and all, in any wood or metal frame you wish. Pick a frame that enhances the overall presentation of the photograph. Standard size mats, like 8" x 10" and 11" x 14", fit ready-made frames, while odd-sized mats require more costly custom-made frames. When selecting the glazing, you have the option of choosing glass or acrylic. Though acrylic glazing scratches more easily than glass, it's lighter and more difficult to break, which makes it a great choice for traveling exhibitions. Acrylics bear-ing the grade "UF1" provide protection from ultraviolet rays. Special non-glare glass is also available — at a special price.

Art supply stores, photo supply stores and do-it-yourself framing shops will be happy to sell you all the supplies you need to mat and frame your art-work — and probably throw in free advice. Or, if you think framing too much of a chore, let them do the work for you.

Archival Considerations

The value of an artwork increases over time, but only if kept in good con-dition. For this reason, galleries and discriminating art buyers place great importance on artwork's archival qualities. Archival preservation begins in the darkroom where proper procedures must be meticulously followed. This means using clean equipment, fresh, properly mixed chemicals and careful washing technique.

Only fiber-based prints are considered to be archival; the emulsion on resin-coated prints is not very durable. Gold or selenium toned prints are considered more archival than ordinary black & white prints. If you want the archival benefits of toning without the esthetic changes to the image, use dilute toning solution.

When archival preservation is paramount, use only top quality artist-grade oils, watercolors or colored pencils to handcolor the print. Other handcol-oring media, such as dyes and markers, fade relatively quickly.

Spray finishing is optional. When matting and framing the finished work, use a hinge mat and acid-free materials.

Displaying Handcolored Photographs

On the Wall or Dresser

At home or in a gallery, light is the handcolored photograph's worst enemy: it contributes to fading, discoloration and embrittlement. Never hang hand-colored photographs in direct sunlight or near a fluorescent light. Another element threatening your photo's life is moisture. Moisture reacts with the print, the coloring media and pollutants in air to form sulfuric acid, which eats away at the print. Moisture also facilitates the growth of mold. To pre-vent moisture damage, don't hang the photograph in the laundry room, kitchen or bathroom. Changes in temperature can also shorten a photo-graph's life. Generally, it's better to hang photographs on interior walls than

Above: Archival photo albums like this one are a beautiful way to present your handcolored images.
Below: This is a color photocopy of a handcolored image. Color copies are one way to quickly reproduce your handcolored images.

• **Light and moisture are harmful to handcolored photographs.**

perimeter walls. Don't hang handcolored photographs over a fireplace or near a heater.

In an Album

Drugstore photo albums that use plastic covers to hold photos in place destroy *all* photographs, not just handcolored ones. When you try to remove the plastic cover, you peel away portions of the photo's surface. A better alternative is archival photo albums that use decorative photo corners to hold prints in place and interleaving pages to protect their surfaces.

In a Portfolio

To transport and present your handcolored photographs to prospective clients, gallery owners or other interested parties, use a box portfolio.

Making Copies

To copy a handcolored photograph, take it to a photo lab and ask them to make a color copy negative. From the negative, you can make as many color prints as you wish. A quicker, less-expensive way to make copies is using a color photocopier, though the lines may not be very crisp and colors may distort.

Cleaning

To clean a framed photograph, dampen a lint-free cloth with glass cleaning fluid, then clean the glazing. Don't squirt the fluid directly on the glazing — it may seep into the frame and stain the mat. Every ten years or so, framed artwork should be opened and inspected for damage. Take the opportunity to clean the inside of the glazing (sometimes coloring media cause a slight haze to form).

Storing

"...store them in print storage boxes..."

Should you create more handcolored photographs than you have wall space, you can store them in print storage boxes made from acid-free board interleaved with acid-free tissue paper. Keep the box in a cool, dark, dry place — not a damp basement. The boxes that photographic papers are sold in are suitable for temporary storage.

Appendix A

Manufacturers and Suppliers

Photographic Film, Paper and Chemical

Agfa USA
100 Challenger Road
Ridgefield Park, NJ 07660
phone: (201)440-2500
fax: (201)440-5733

Agfa Canada
77 Belfield Road
Etobicoke, Ontario M9W 1G6 Canada
phone: (416)241-1110
fax: (416)241-5409

Berg Color Tone
72 Ward Road
Lancaster, NY 14086-9779
phone: (716)681-2696
fax: (716)684-0511

Ilford USA
West 70 Century Road
P.O. Box 288
Paramus, NJ 07653
phone: (201)265-6000 ext. 213

Ilford Canada
2751 John Street
Markham, Ontario L3R 2Y8 Canada
phone: (905)940-4455

Kodak Information Center USA
phone: 1-800-242-2424

Kodak Information Centre Canada
phone: 1-800-GO-KODAK

Luminos
P.O. Box 158
Yonkers, NY 10705
phone: 1-800-LUMINOS

Photographer's Formulary
P.O. Box 950
Condon, MT 59826
phone: 1-800-922-5255 or (406)754-2891

Art Supplies

Berol Corporation
105 West Park Drive
P.O. Box 2248
Brentwood, TN 37024-2248

ColArt Americas Inc.
11 Constitution Avenue
P.O. Box 1396
Piscataway, NJ 08855-1396

Caran d'Ache
19 Chemin du Foron
Case Postale 169
1226 Thonex-Geneve Switzerland

Dale-Rowney USA
4 Corporation Drive
Cranbury, NJ 08512-9584

Daniel Smith
4130 First Avenue South
Seattle, WA 98134-2302
phone: 1-800-426-6740

Dr. Ph. Martin's Synchromatic Transparent Water Color
c/o Salis International, Inc.
4093 N. 28th Way
Hollywood, Florida 33020
phone: 1-800-843-8293 or (305)921-6971

M. Grumbacher Inc.
100 North Street
Bloomsbury, NJ 08804

John G. Marshall Mfg. Co. Inc.
P.O. Box 649
Deerfield, IL 60015

Pentel of America Ltd.
2805 Torrance Street
Torrance, CA 90503

Pentel Stationery of Canada Ltd.
160-5900 No. 2 Road
Richmond, British Columbia V7C 4R9 Canada

Sennelier
Rue du Moulin a Cailloux
Orly Senia 408
94567 Rungis Cedex France

Winsor & Newton Inc.
11 Constitution Avenue
P.O. Box 1396
Piscataway, NJ 08855-1396

Appendix B

Coloring Media Guide

The following chart lists the advantages and disadvantages of the different coloring media described in this book.

Medium	Description	Advantages	Disadvantages
Oil paints	Rich, smooth paints applied with cotton or a brush	• hundreds of colors available including metallics • leave a smooth, professional finish • easy to correct mistakes • excellent permanency	• slow drying
Oil pastels	Rich colors applied directly on photo	• easy to handle • inexpensive • easy to correct mistakes	• difficult to apply smoothly
Oil bars and sticks	Rich colors applied directly on photo	• glitter and fluorescent colors available	• extremely sticky, difficult to blend • large size makes them unwieldy • limited color selection
Oil crayons	Rich, waxy crayons applied directly on photo	• good for adding texture	• opaque • limited color selection
Photo oils	Rich, smooth, translucent colors applied with cotton	• leave a smooth, professional finish • easy to correct mistakes • matching pencils for detail work available	• slow drying • limited color selection • relatively expensive
Watercolor paints	Luminous, translucent colors applied directly on photo	• water is the only solvent needed • hundreds of colors available • very easy to remove	• difficult to apply, tend to run • water-soluble, even when dry
Watercolor pencils	Luminous, translucent colors applied directly on photo	• easy to use • excellent for coloring details	• difficult to blend or mix colors • limited color selection
Watercolor crayons	Luminous, bright, waxy crayons applied directly on photo	• easy to use	• opaque, heavy texture
Brilliant watercolors	Bright, strong colors applied with cotton or a brush	• brightest of all media	• difficult to apply • very difficult to remove colors • colors easily fade
Colored pencils	Bright, flat colors applied directly on photo	• easy to handle • excellent for coloring details	• leave visible strokes
Acrylic paints	Opaque, bright colors applied with a brush	• good for creating texture • water-soluble when wet, water-proof when dry • very quick drying	• opaque
Retouching dyes	Dyes used for retouching color photos, applied with brush	• stick to all photo surfaces, even glossy finishes	• limited color selection • difficult to remove color • relatively expensive
Markers	Bold colors applied directly on photo	• easy to handle	• difficult to blend smoothly • difficult to remove mistakes
Chemical toners	Change overall tone of photo, print immersed in solution	• some improve archival stability of print • often used to warm-up skin tones in portraits	• time consuming process • results somewhat unpredictable • some require special handling • awkward to use at home
Mordant dyes	Bright colors achieved by immersing print in dye bath	• range of very bright colors	• color entire print same color • time consuming process • color fades in sunlight • awkward to use at home

Glossary

acid-free materials: Materials containing no glues or acids harmful to the print. Used when framing to archival standards.

acrylic bridge: A hand rest used while handcoloring to prevent smudging colors.

acrylic paint: Opaque, water-based paint invented in the 1940's. Consists of pigments suspended in an acrylic emulsion.

airbrush: A mechanical device that uses compressed air to shoot liquid paint through a nozzle. Often used by graphic artists.

archival standards: Standards for processing, coloring and storing film and photographs to ensure their maximum life span. When working to archival standards, you generally use artist-grade coloring media and acid-free framing materials.

artist-grade: The highest grade of paints and coloring materials available. Artist-grade materials use top quality pigments for intense, lightfast color. See student-grade.

barrier cream: A cream rubbed onto your hands before coloring to make it easier to clean paint from your skin. Sometimes called "invisible gloves."

Berg Color Toning System: A color toning kit manufactured by Berg containing a number of vividly colored dyes. See mordant dyes.

brilliant watercolors: Bright liquid watercolors commonly used by graphic artists.

burning in: Giving increased light to a portion of the print during exposure to darken it. See dodging.

canvas: A general term that refers to the material on which you create art. When handcoloring, the photo is your canvas.

cold tone paper: Photographic paper with a bluish base tone. See warm tone paper.

color theory: A system of observations used to help artists understand and use color effectively. Encompasses topics such as color mixing and harmonizing.

color wheel: A handy, circular chart that helps predict the result when two colors are mixed.

colored pencil: A pencil with a lead made from wax-bound pigment instead of graphite. Excellent for coloring details.

colorless marker: A marker that has no color of its own but contains a solvent that smoothes pencil or marker strokes.

coloring media: Any material used to add color to a black and white photo. Oil paints, watercolors, colored pencils and markers are just a few of the available coloring media.

complementary colors: Colors opposite one another on the color wheel. For example, red and green are complementary colors. Placed side by side, complementary colors contrast and intensify one another. See color wheel.

cool color: A color biased toward blue. Cool colors are generally perceived as fresh, calm and soothing. See warm color.

darkroom techniques: Techniques used to control the appearance of a photographic print while developing the print in the darkroom. Burning in and dodging are examples of darkroom techniques.

daylight balanced bulb: A light bulb that simulates sunlight. Handcolorists use daylight balanced bulbs so they can accurately evaluate colors.

developer: The chemical that causes the latent image on the photographic paper or film to appear.

dodging: Restricting light to an area of the print during exposure to keep it lighter than the rest of the print. See burning in.

drafting table: A table specially designed for drafting or drawing, usually with adjustable height and incline.

drafting tape: A tape similar to masking tape, but less sticky.

drier: A gel that can be mixed into oil paints before coloring to reduce drying time.

dye: A liquid used to color a photograph by staining the print's emulsion.

edge halo: Ridges of color between objects on a handcolored photo. Caused by failure to overlap color.

emulsion: The chemical coating on photographic paper and film.

eraser shield: A thin metal template used to isolate small details on a photo so you can color or erase with precision.

exposure: The step in the development process where the photographic paper is exposed to light.

fiber-based paper: A type of photographic paper coated with clay under the emulsion. Generally regarded as the best paper for handcoloring. See resin-coated paper.

finish: A term used to describe the relative glossiness of the surface of photographic paper. The three standard paper finishes are matte, pearl and glossy.

fixer: A chemical used when developing a print to stabilize the image on the paper.

French curves: Plastic templates useful for coloring around curved areas.

frisket paper: A clear plastic film, slightly adhesive on one side, used to mask portions of the photo you don't want colored. Particularly useful for toning and dyeing.

gouache: Watercolor paint thickened with chalk to make it opaque. Sometimes called designer's paint or poster paint.

hinge mat: A common method of mounting a photo in a frame. The mat is hinged to a backboard with tape, then the photo is secured to the backboard using photo corners.

hue: Another way to say color.

hypo eliminator solution: A washing aid that removes residual fixer from photographic paper or film before the final wash. Helps prevent staining and deterioration of the paper or film.

imprimatura: The technique of coloring the entire photo one solid base color, then layering all other colors on top. Results in complex color mixing which serves to unify the color scheme. See layering.

ink: Liquid, water-based color usually applied with a pen or airbrush.

intensity: A term used to describe the brightness or dullness of a color.

layering: The technique of applying one color on top of another. The purpose of layering is to build the intensity of a color or to mix colors.

lightfastness: A measure of a medium's resistance to fading when exposed to light.

light sensitive: A term used to describe photographic chemicals and materials that deteriorate in the presence of light. Light sensitive materials must be used only in a darkroom under a red safe light. Photographic film, for example, is light sensitive.

mahlstick: A long stick with a padded end used as a hand rest while handcoloring to prevent smudging colors.

markers: Common felt-tip markers that may be used to color photographs. Some markers are water-based, others solvent-based.

Marshall Photo Oils: A popular brand of oil paints specially formulated for handcoloring photographs. Slightly thinner in consistency than regular oil paints.

mask: Any material used to cover the portion of the photo you don't want colored. Liquid, paper and plastic masks are available.

masking fluid: A fluid used to mask portions of a photo you don't want colored. Often used with watercolors and dyes.

mat board: A thick sheet of pressed paper commonly used to mount photographs.

mineral spirits: A petroleum distillate used as a paint thinner. See solvents.

mordant dyes: A type of dye that employs an activator to chemically alter the silver on the emulsion so the dye will adhere to it.

oil bar: A large, sticky pastel. See oil pastel.

oil-based media: Any coloring medium consisting of pigments bound with drying oils such as linseed or poppy oil. This includes oil paints, oil pastels, oil bars, oil sticks, oil crayons and oil pencils.

oil crayon: Similar to an oil pastel, but slightly waxier. See oil pastel.

oil paint: Paint consisting of finely ground pigments suspended in an oil base. One of the most common handcoloring media.

oil pastel: Oil paint bound with resins, compressed calcium carbonate and wax and shaped into stick form.

oil pencil: Essentially a thin oil pastel encased in wood. See oil pastel.

oil stick: See oil bar.

optical mixing: Dotting a photograph with different colors to create the illusion of mixed color when viewed from a distance.

organic dye: A dye derived from natural, rather than synthetic, sources.

palette: The tray used to hold and mix paints when handcoloring.

paper characteristics: The unique qualities of photographic paper that vary from manufacturer to manufacturer. The main characteristics are paper type, finish and tone.

pencil lengthener: A device designed to make short, worn pencils easier to hold.

photo oils: Oil paints that have been specially manufactured or marketed for handcoloring photographs. The most popular brand is Marshall's.

pigment: The material that gives paint and other coloring media their color. Pigments can be produced from mineral, plant or animal sources or from synthetic materials. Cobalt, for example, is used to create cobalt blue.

primary colors: Red, yellow and blue are the three primary colors. In theory, all other colors can be created by combining the primaries plus black and white.

resin-coated paper: Photographic paper coated with polyethylene on both sides to make it water resistant and reduce the processing time. Generally acceptable for most handcoloring applications.

reticulation: A spider web-like pattern that appears on a print when the temperature of the chemicals is deliberately raised and lowered during processing.

retouching dyes: Colored dyes used to retouch color photographs to hide scratches, dust marks and other defects.

secondary colors: A mixture of two primary colors. For example, violet is the secondary color created by mixing equal amounts of red and blue.

selective toning: A toning technique in which only some portions of the photo are toned.

shade: A mixture of a color with black. For example, crimson is a shade of red.

solarization: The technique of flashing light on a developing print to achieve unusual and unpredictable results. Usually reverses the print's tones. Sometimes called "sabattier."

solvent: A liquid that can dissolve other materials. When using oil-based coloring media, turpentine or mineral spirits is used as the solvent. For water-based media, water is the solvent.

split toning: A method of toning that intensifies the contrast between highlights and shadows.

spotting dye: A black dye used to retouch black and white photographs to hide scratches, dust marks and other defects.

spray fixative: An aerosol spray applied to the surface of a handcolored photo to protect it from moisture and contaminants.

student-grade: An inexpensive, but generally acceptable grade of coloring materials. Student-grade materials use lower quality pigments and may not be as bright, intense or lightfast as higher grade materials. See artist-grade.

tertiary colors: A mixture of a primary and secondary color. For example, blue-green is a tertiary color.

three primary system: The theory that all colors can be mixed from the three primary colors, red, yellow and blue. Used to predict the outcome when colors are mixed.

tint: A mixture of a color with white. For example, pink is a tint of red.

tonal range: The range of grays that can be reproduced on photographic paper.

tone: A mixture of a color with gray.

toner: A chemical solution used to change the overall color of a print by replacing the silver in the emulsion with another metal such as iron or gold.

transparentizing gel: A clear gel that can be added to oil paints to increase their transparency. This allows you to color a photo with oil paint without obscuring the image.

warm color: A color biased toward red. Warm colors are generally perceived as bold and vibrant. See cool color.

warm tone paper: Photographic paper with a brownish base tone. See cold tone paper.

watercolors: Water-soluble paint available as liquid in tubes or as dry cakes in palettes. Produces delicate, translucent color.

watercolor crayon: Watercolor paint in crayon form.

watercolor pencil: Watercolor paint mixed with binders and encased in wood. Often used to color details after the rest of the print has been colored with watercolor paints.

wax bloom: A hazy coating that can form on a photo colored with pencils. Caused by wax working its way to the surface of the photo.

wetting agent: A substance used to keep the surface of a print evenly damp while coloring with watercolors. Oxgall liquid and Kodak Photo Flo are two common wetting agents.

ultraviolet absorber: A spray used to protect a handcolored photograph from harmful ultraviolet rays. See spray fixative.

value: A term used to describe the lightness or darkness of a color.

Index

Other Books from Amherst Media, Inc.

Basic 35mm Photo Guide
Craig Alesse

Great for beginning photographers! Designed to teach 35mm basics step-by-step — completely illustrated. Features the latest cameras. Includes: 35mm automatic and semi-automatic cameras, camera handling, f-stops, shutter speeds, and more! $12.95 list, 9 x 8, 112 p, 178 photos, order no. 1051.

Infrared Photography Handbook
Laurie White

Totally covers black and white infrared photography: focus, lenses, film loading, film speed rating, heat sensitivity, batch testing, paper stocks, and filters. Black & white photos illustrate how IR film reacts in portrait, landscape, and architectural photography. $24.95 list, 8 1/2 x 11, 104 p, 50 B&W photos, charts & diagrams, order no. 1419.

Wedding Photographer's Handbook
Robert and Sheila Hurth

The complete step-by-step guide to photographing weddings – everything you need to start and succeed in the exciting and profitable world of wedding photography. Packed with shooting tips, equipment lists, must-get photo lists, business strategies, and much more! $24.95 list, 8 1/2 x 11, 176 p, index, b&w and color photos, diagrams, order no. 1485.

Glamour Nude Photography
Robert and Sheila Hurth

Create stunning nude images! Robert and Sheila Hurth guide you through selecting a subject, choosing locations, lighting, and shooting techniques. Includes information on posing, equipment, makeup and hair styles, and much more! $24.95 list, 8 1/2 x 11, 144 p, over 100 b&w and color photos, index, order no. 1499.

Lighting for People Photography
Stephen Crain

The complete guide to lighting and its different qualities. Includes: set-ups, equipment information, how to control strobe and natural lighting, and much more! Features diagrams, illustrations, and exercises for practicing the lighting techniques discussed in each chapter. $24.95 list, 8 1/2 x 11, 112 p, b&w and color photos, glossary, index, order no. 1296.

Wide-Angle Lens Photography
Joseph Paduano

For everyone with a wide-angle lens or people who want one! Includes taking exciting travel photos, creating wild special effects, using distortion for powerful images, and much more! Part of the Amherst Media's Photo-Imaging Series. $15.95 list, 7 x 10, 112 p, glossary, index, appendices, b&w and color photos, order no. 1480.

Big Bucks Selling Your Photography
Cliff Hollenbeck

A complete photo business package for all photographers. Includes secrets to making big bucks, starting up, getting paid the right price, and creating successful portfolios! Features setting financial, marketing and creative goals. This book will help to organize business planning, bookkeeping, and taxes. $15.95 list, 6x9, 336 p, Hollenbeck, order no. 1177.

Camera Maintenance & Repair
Thomas Tomosy

A step-by-step, fully illustrated guide by a master camera repair technician. Sections include: testing camera functions, general maintenance, basic tools needed and where to get them, basic repairs for accessories, camera electronics, plus "quick tips" for maintenance and more! $24.95 list, 8 1/2 x 11, 176 p, order no. 1158.

McBroom's Camera Bluebook
Mike McBroom

Comprehensive, fully illustrated, with price information on: 35mm cameras, medium & large format cameras, exposure meters, strobes and accessories. Pricing info based on equipment condition. A must for any camera buyer, dealer, or collector! $24.95 list, 8x11, 224 p, 75+ photos, order no. 1263.

Zoom Lens Photography
Raymond Bial

Get to know the most versatile lens in the world! Includes how to take vacation, landscape, still life, sports and other photos. Features product information, accessories, shooting tips, and more! Part of the Amherst Media's Photo-Imaging Series. $15.95 list, 7 x 10, 112 p, b&w and color photos, index, glossary, appendices, order no. 1493.

Great Travel Photography
Cliff and Nancy Hollenbeck

Learn how to capture great travel photos from the Travel Photographer of the Year! Includes helpful travel and safety tips, packing and equipment checklists, and much more! Packed full of photo examples for all over the world! Part of the Amherst Media's Photo-Imaging Series. $15.95 list, 7 x 10, 112 p, b&w and color photos, index, glossary, appendices, order no. 1494.

Infrared Nude Photography
Joseph Paduano

A stunning collection of natural images with wonderful how-to text. Over 50 infrared photos. Shot on location in the natural settings of the Grand Canyon, Bryce Canyon and the New Jersey Shore. $19.95 list, 9 x 9, 80 p, over 50 photos, order no. 1080.

Make Fantastic Home Videos
John Fuller

Create videos that friends and relatives will actually want to watch! After reviewing basic equipment and parts of the camcorder, this book tells how to get a steady image, how to edit while shooting, and explains the basics of good lighting and sound. Sample story boards and storytelling tips help show how to shoot any event. $12.95 list, 7 x 10, 128 p, fully illustrated, order no. 1382.

Build Your Own Home Darkroom
Lista Duren & Will McDonald

This classic book shows how to build a high quality, inexpensive darkroom in your basement, spare room, or almost anywhere. Information on: darkroom design, woodworking, tools, and more! $17.95 list, 8 1/2 x 11, 160 p, order no. 1092.

Into Your Darkroom Step-by-Step
Dennis P. Curtin

The ideal beginning darkroom guide. Easy to follow and fully illustrated each step of the way. Information on: equipment you'll need, set-up, making proof sheets and much more! $17.95 list, 8 1/2 x 11, 90 p, hundreds of photos, order no. 1093.

The Freelance Photographer's Handbook
Fredrik D. Bodin

A complete handbook for the working freelancer. Full of how-to info & examples. Includes: marketing, customer relations, inventory systems, portfolios, and much more! $19.95 list, 8 x 11, 160 p, order no. 1075.

Lighting for Imaging
Norman Kerr

This book explains light: what it is, how to use it, and how to control it. It shows how to use any light source for any form of photographic imaging — including film, digital, or video. Learn to use light like an expert: from taking videos of your family trips to polishing your professional work. $26.95 list, 8 1/2 x 11, 144 p, color and b&w illustrations, order no. 1490.

The Wildlife Photographer's Field Manual
Joe McDonald

The complete reference for every wildlife photographer. A practical, comprehensive, easy-to-read guide with useful information, including: the right equipment and accessories, field shooting, lighting, focusing techniques, and more! Features special sections on insects, reptiles, birds, mammals and more! $14.95 list, 6 x 9, 200 p, order no. 1005.

Camcorder Business
Mick and George A. Gyure

Make money with your camcorder! This book covers everything you need to start a successful business using your camcorder. Includes: editing, mixing sound, dubbing, technical and business tips, and much more! Also features information on covering a wedding or other special event for a client, legal and industrial videos, and more. $17.95 list, 7 x 10, 256 p, order no. 1496.

More Photo Books Are Available

Write or fax for a *FREE* catalog:
Amherst Media, Inc.
PO Box 586
Buffalo, NY 14226 USA

Fax: 716-874-4508

Amherst Media's Customer Registration Form

Please fill out this sheet and send or fax to receive free information about future publications from Amherst Media.

CUSTOMER INFORMATION

DATE

NAME

STREET OR BOX #

CITY STATE

ZIP CODE

PHONE () FAX ()

OPTIONAL INFORMATION

I BOUGHT *HANDCOLORING PHOTOGRAPHS STEP-BY-STEP* BECAUSE

I FOUND THESE CHAPTERS TO BE MOST USEFUL

I PURCHASED THE BOOK FROM

CITY STATE

I WOULD LIKE TO SEE MORE BOOKS ABOUT

I PURCHASE BOOKS PER YEAR

ADDITIONAL COMMENTS

FAX to: 1-800-622-3298

Name_____
Address_____
City_____State_____
Zip_____ — _____

Place
Postage
Here

Amherst Media, Inc.
PO Box 586
Buffalo, NY 14226